IMAGES
of America

ARIZONA'S
HISTORIC BRIDGES

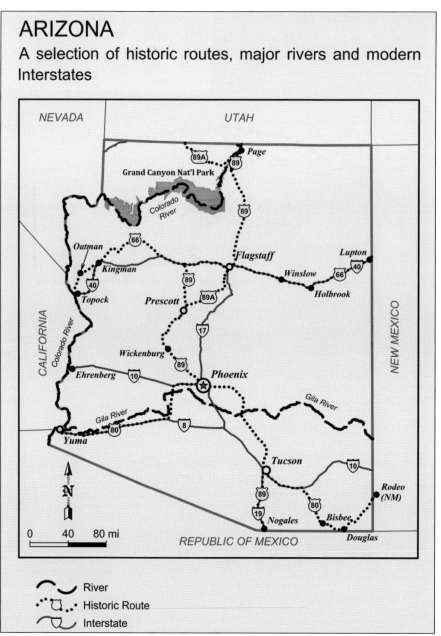

ARIZONA
A selection of historic routes, major rivers and modern Interstates

NEVADA UTAH

[89A] Page [89]

Grand Canyon Nat'l Park

Colorado River

[89]

[66] Oatman

Flagstaff Lupton [40]

Kingman [89] Winslow [66]

[40] Holbrook

Topock Prescott [89A]

CALIFORNIA

Colorado River

[17]

Wickenburg

Ehrenberg [10] [89] Phoenix

Gila River

Gila River [8]

[80]

Yuma

Tucson [10]

NEW MEXICO

Rodeo (NM)

[89]

[19] Nogales [80] Bisbee

Douglas

REPUBLIC OF MEXICO

N

0 40 80 mi

〜 River
∴🔲∴ Historic Route
〜🔲 Interstate

STATE TRANSPORTATION ROUTES. This map shows the historic transportation routes in Arizona. All of the historic bridges profiled in this book can be found along or near these routes. (Map by Terry Couchenour.)

ON THE COVER: 1915 OCEAN-TO-OCEAN HIGHWAY BRIDGE AND 1924 RAILROAD BRIDGE: The Ocean-to-Ocean Highway Bridge is shown in this vintage photograph. The first vehicular crossing of the Colorado River was at Yuma, where the river narrowed. The site was designated as the Yuma Crossing National Heritage Area in 2000. The railroad bridge, built in 1924, is on the left in the photograph. The Ocean-to-Ocean Highway Bridge, on the right, was built in 1915. (Courtesy of Arizona Department of Transportation.)

IMAGES
of America

ARIZONA'S
HISTORIC BRIDGES

Jerry A. Cannon and Patricia D. Morris

ARCADIA
PUBLISHING

Published by Arcadia Publishing
Charleston, South Carolina

Printed in the United States of America

Library of Congress Control Number: 2014957939

For all general information, please contact Arcadia Publishing:
Telephone 843-853-2070
Fax 843-853-0044
E-mail sales@arcadiapublishing.com
For customer service and orders:
Toll-Free 1-888-313-2665

Visit us on the Internet at www.arcadiapublishing.com

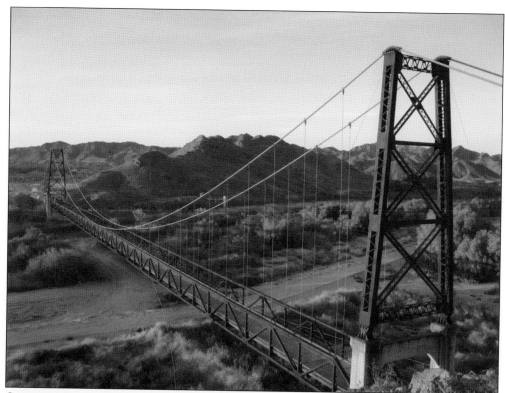

CLOSED MCPHAUL BRIDGE. The McPhaul Bridge spans the Gila River near Yuma, Arizona. The bridge is currently closed, but it offers the promise to be rehabilitated and reopened as a pedestrian bridge to Arizona residents and tourists. (Courtesy of Wikimedia Commons.)

CONTENTS

ACKNOWLEDGMENTS

Obtaining the photographs and writing the captions for this book was a fun thing to do, but it took the cooperation and assistance of many individuals and institutions.

The authors drew from their own photography collections and from the following, to whom they are deeply indebted: Karen Feeney, for assembling the photographs and text for the book; Barbara Winters, for her editing assistance; Terry Couchenour, Cochise County right-of-way agent, for map preparation; Dolores Cannon, for her support and assistance, Fraser Design and EcoPlan, for the use of the Arizona Historic Bridge Inventory; the Arizona Department of Transportation Bridge Group and Creative Services Group, for sharing their collection of vintage photographs; California Department of Transportation; US Bureau of Reclamation; Mary Lou Vaughan, for sharing information about her father, Ralph Hoffman; Donna Johnson, for sharing information about her grandfather, Harry McPhaul; Arizona State Historical Society; Arizona State Archives; Sharlot Hall Museum; Northern Arizona University, Cline Library; State Historic Preservation Office; Tammy Shook, Yuma Quartermaster Depot Historic Park; and many others for their encouragement and direction.

Unless otherwise noted, all images appear courtesy of the authors.

INTRODUCTION

The history of Arizona began long before the arrival of Europeans, but most of the oral stories of Native Americans were not written down. It would take the efforts of archeologists and anthropologists to reveal many of them. The Spanish explorers came in 1593, with Fray Marcos de Niza, followed by Francisco Vasquez de Coronado, and they kept detailed records of their journeys. Arizona was part of the state of Sonora, Mexico, until the Mexican-American War ended in 1848. Arizona's territorial boundary with Mexico became the Gila River. It would take the Gadsden Purchase in 1853 to establish the future state's southern boundary. This block of land, which also included a part of New Mexico, was purchased to extend the transcontinental railroad westward along a southern route. The building of the railroads and bridges created bawdy towns overnight, but they lasted only as long as the project. Roadways were built alongside many of the railroads, and the automobile soon eclipsed the rail and wagon paths.

Arizona became a state when Pres. William Howard Taft signed the statehood bill on Valentine's Day in 1912 surrounded by an entourage of politicians and local Arizonans. Carl Hayden, Arizona's first congressman and champion of many public works and infrastructure projects, was somewhere in that room. New Mexico had been declared a state five weeks earlier, and the *Titanic* would sink only two months later. These events, hopeful and tragic, would portend the interesting times to come for the nation's sixth-largest state.

The declaration of statehood jump-started the building of bridges, dams, and highways. Most of the early bridges were concrete and could span only short chasms, but with the appointment of territorial and state engineers, the structures became more sophisticated and utilized the latest design concepts. J.B. Girand, Lamar Cobb, Daniel Luten, and Ralph Hoffman are some of the early engineers who made their mark by progressively advocating new building methods and materials while trying to keep costs down, a dilemma that has yet to be solved. Concrete arch bridges eventually evolved to allow longer spans. Steel trusses, with their plethora of patented types (Warren, Pony, Pratt, Camelback, and others), came into vogue. The steel parts were fabricated in the Midwest. Local labor, including prisoners, Native Americans, former miners, and farmers, was used to construct the abutments and piers as a cost-saving measure. These workers often had to fabricate tools, bolts, and other parts in the field, since it would have taken too long to get factory replacements.

The public was becoming tired of the rusting steel structures, which reminded them of places they had left. With the World's Columbian Exposition in Chicago in 1893, people came to appreciate what an ideal city could look like, with white streetlights, clean buildings and bridges with elegant lines, and hard-surfaced streets. The City Beautiful movement was born. It focused on the systems of city life that could be controlled by a local government: public building styles, zoning, parks, transportation, and streetscapes. It was an interdisciplinary approach to urban design and infrastructure planning.

In Arizona, pressure was building for longer spans and more aesthetically appealing bridges. Luten concrete arches with decorative side railings, similar to those seen at the Chicago fair, became popular throughout the state (Padre Canyon, Winkelman, Miami, Holbrook). Steel suspension bridges were built over the Little Colorado River (Cameron Bridge) and Gila River (McPhaul Bridge). Another idea put forth by the young state bridge engineer Ralph Hoffman was to build the majority of the mass of the structure underneath the bridge. He did not want it to detract from the visual surroundings, whether it was the magnificent Marble Canyon near the Grand Canyon, or the rather minor Sand Hollow Wash near the Nevada-Utah border. The innovative practices of these engineers, and public opinion, were critical in the evolution of Arizona bridges. Some of the modern bridges utilize the visionary practices of these early pioneers to integrate the structure into the landscape and to recognize its natural beauty. Other bridges have aesthetically suffered from concerns over lawsuits and have been designed with so many safety features that drivers are unaware they are crossing a bridge and that there is a view over the side.

In 2012, as part of the centennial celebrations of Arizona statehood, the coauthors put together a slide show about Arizona's historic bridges, most of which are in the National Register of Historic Places. The presentation was taken on the road throughout the state and delivered to various engineering and historical groups. Feedback was positive, but almost everyone wanted to find out the location of and more information about these historic bridges. Hence, this book project was born. It is organized around the major historical routes or roads as much as possible and gives general directional information so that the reader can explore the exact coordinates via other sources, such as the website of the National Register of Historic Places. Some of the bridges appear in more than one chapter because they were the focal points of the ever-changing routes. It was often a challenge to figure out where a bridge was in relation to the historic route, and vice versa.

Engineering and hydrology are not perfect sciences. Judgment is required, and early engineers did not have the data to readily analyze the unpredictable seasonal flows and scour patterns of Arizona's watercourses. Other bridges were designed for much lighter loads than what is needed for today's vehicles. Many bridges did not survive, but they were usually replaced with a better design. Some have been restored to their original glory. There are many, however, that need attention and large amounts of money. Local governments have many challenges when it comes to funding, but with the assistance of the federal government, there are great examples around the state that link bridge rehabilitation with economic and tourism resurgence. We hope that this book can elevate enthusiasm for restoration efforts or, if nothing else, encourage a very cool road trip or two.

One

US ROUTE 66

Route 66, from Chicago to Los Angeles, did not follow a predictable or historic route, as did other major highways at the time. It dug its way diagonally across Illinois and Missouri and dipped south into Oklahoma before heading west to California. Politics and personalities influenced its direction, because local governments participated in the process of choosing interstate routes. Even the number assigned to it by the American Association of Highway Officials in 1926 was inconsistent with other major routes, but it would later be lyrically memorialized as a road of adventure and new opportunities. It would carry with it other names, such as Will Rogers Highway, National Old Trails Highway, Santa Fe Highway, Main Street of America, and Mother Road.

In Arizona, the highway generally followed the route established by Lt. Edward Fitzgerald Beale in 1857. He was assigned the task of surveying a wagon road along the 35th parallel, and he experimentally used camels as his main instrument animals, rather than mules or horses. When the economy rebounded after the Civil War, the Atlantic & Pacific Railroad (later the Atchison, Topeka & Santa Fe Railroad) built tracks along the road that Beale had surveyed. The task was finished in 1883, connecting both coasts. Route 66 followed a similar alignment in the 1920s, but to reduce costs, it avoided some of the deeper gorges traversed by the railroad. Canyon Diablo is a good example of this. The railroad crossed a deep, wide part of the canyon, but the road went over a much shallower section of the same canyon. As Route 66 headed west, however, deep canyons and rivers were unavoidable.

The road bridges profiled in this chapter, starting at Lupton and ending at Topock, are on the original Route 66 or near it. The bridges were narrow, barely wide enough to fit two vehicles, and constructed of a variety of materials. The federal government enabled this aggressive bridge construction by providing funds. These bridges still exist not far from Interstate 40. They are either maintained by local governments or have been abandoned.

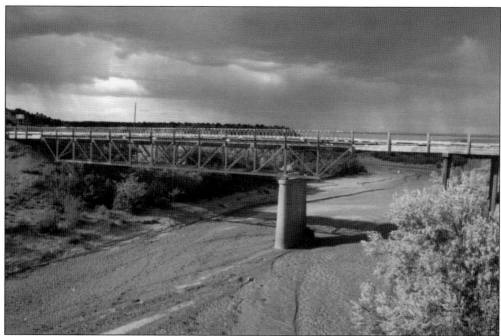

ALLENTOWN BRIDGE, BUILT 1923. This bridge across the Rio Puerco River is the first historic bridge on old Route 66 as one enters Arizona from New Mexico. This span, and the bridge at Sanders, were important links on Route 66 until 1931, when the road was rerouted. Ralph Hoffman designed it early in his career with the Arizona Department of Transportation. It is unique in the way the trusses cantilever over the pier walls.

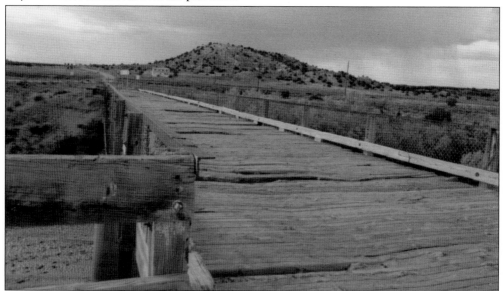

ALLENTOWN BRIDGE TODAY. Before the bridge was built, long waits to cross the Rio Puerco River were normal. In early bridges, wood was commonly used for decks and approaches, because it was available locally, was cheaper than steel, and local labor could be used. The bulk of bridge money went into the steel trusses, piers, and abutments. This span is located south of the Interstate 40–Allentown interchange.

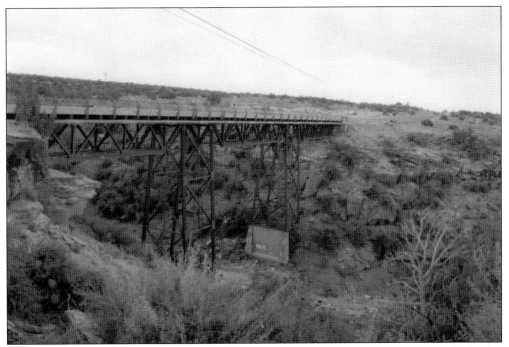

QUERINO CANYON BRIDGE, BUILT 1930. As this canyon is wider than the Rio Puerco, the bridge required three spans and tall steel towers supported on concrete piers. Once part of Route 66, it is now maintained by Apache County and generally used for local Navajo Nation traffic. It is located on Querino Road, north of Interstate 40.

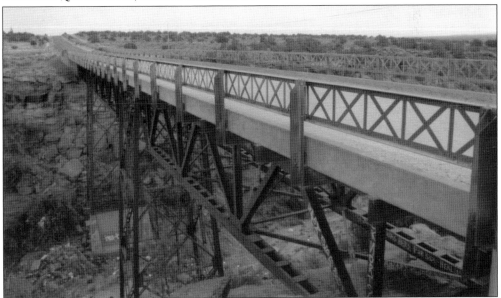

QUERINO CANYON BRIDGE PIER TOWERS. State bridge engineer Ralph Hoffman designed the Querino Canyon Bridge as well as the very similar Sand Hollow Wash Bridge in northwest Arizona. Special features of both bridges are the steel pier towers with battered legs, a shape that Gustave Eiffel had previously used on the Garabit Viaduct (1884) in south central France and on the Eiffel Tower (1889) in Paris.

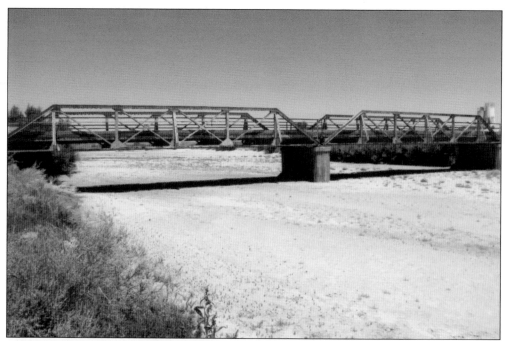

SANDERS BRIDGE, BUILT 1923. Located on the same Rio Puerco River as the Allentown Bridge, this structure also has a wooden deck and approach spans. Sanders is one of the earliest examples of a Pratt steel pony truss bridge built by the Arizona Department of Transportation. It carried traffic until 1931, when the road was realigned and the bridge was abandoned.

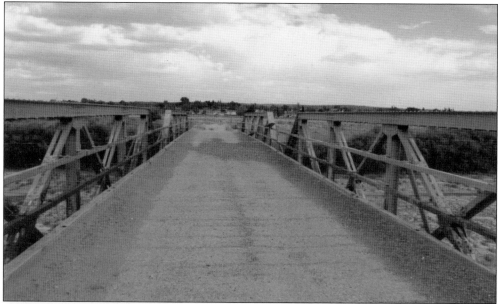

SANDERS BRIDGE TODAY. Funds to construct these bridges were scarce, and costs were pared down by using wooden decks and approach spans rather than costly steel trusses and concrete decks. However, wood was a short-term solution because it deteriorated under the harsh Arizona weather and was easily damaged by flooding, which undermined the supports. Fires under and on the bridge (caused by dysfunctional automobiles) also contributed to the failures.

PETRIFIED FOREST AGATE BRIDGE.
In 1906, Pres. Theodore Roosevelt
established the Petrified Forest National
Monument, citing "the mineralized
remains of the Mesozoic forest as having
great scientific interest and value." The
tree shown here fell on solid ground
eons ago, but erosion took away the
earth underneath, thereby forming the
bridge. In 1962, the monument was
upgraded to a national park, the only
park that Route 66 passes through.
(University of Southern California
Archives, California Historical Society.)

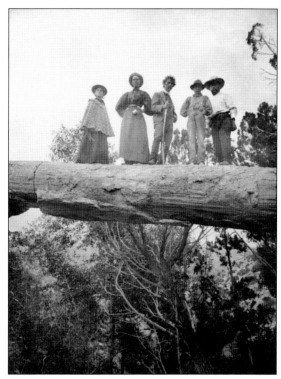

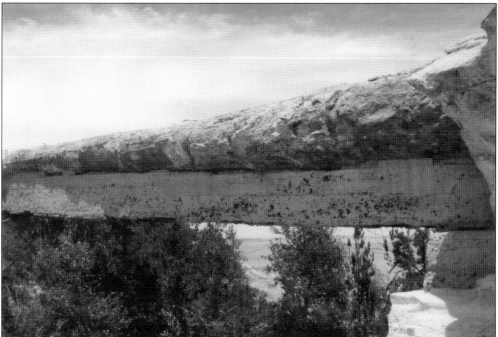

PETRIFIED FOREST AGATE BRIDGE TODAY. Several attempts have been made by conservationists
to keep the formation intact. In the early 1900s, several stone piers were constructed under the
log for support, but these eventually washed away. In the 1930s, this concrete beam was built, and
it still exists today. This solution would not be adopted by modern conservationists.

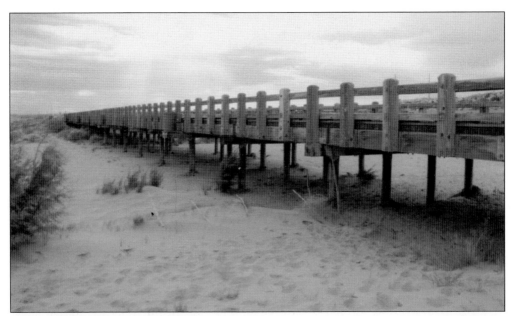

CARRIZO BRIDGE, BUILT 1932. The branches of the Lithodendron Wash cross what was Route 66 in several places. A pair of identical timber trestle bridges was built across it, south of Interstate 40. This bridge, the only one still used for local traffic, can be briefly viewed as one speeds by on the interstate or on the frontage road.

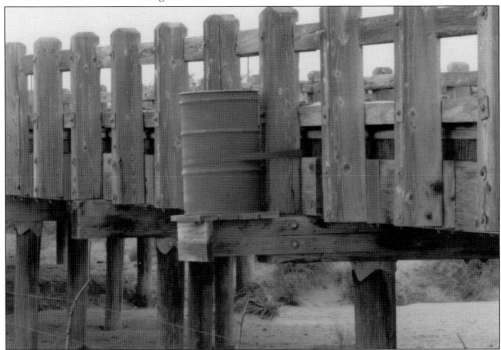

CARRIZO BRIDGE WATER BARRELS. Carrizo Bridge was rehabilitated in 1986, including the retention of the metal water barrels supported on the bridge pier beams. Placing water barrels on a wooden bridge to put out a fire may have been a solution, but only if water was kept in the barrels and someone could lift them.

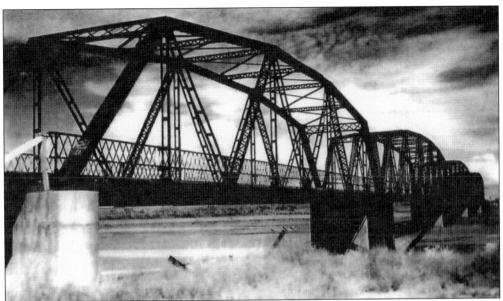

WINSLOW BRIDGE, BUILT 1917. The Little Colorado River is a formidable crossing, as it sees significant flooding. This crossing, east of Winslow and south of Interstate 40, required four spans of steel trusses. Even though this is a rather standard Warren through truss design, the polygonal shape of the top chord makes it unusual. The bridge carried Route 66 traffic until 1939, when it was replaced. (Arizona Department of Transportation.)

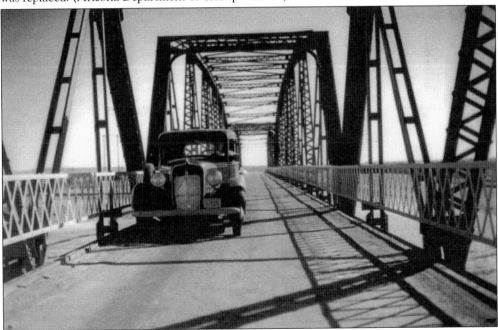

WINSLOW BRIDGE. This bridge was only 13 feet wide, making it difficult for two vehicles to pass from both directions and causing traffic delays on Route 66. The state finally decided to replace it. Navajo County moved one of the spans to the Woodruff-Snowflake location over the Little Colorado River. The practice of reusing trusses from an earlier structure was a trend employed by the state. (Arizona Department of Transportation.)

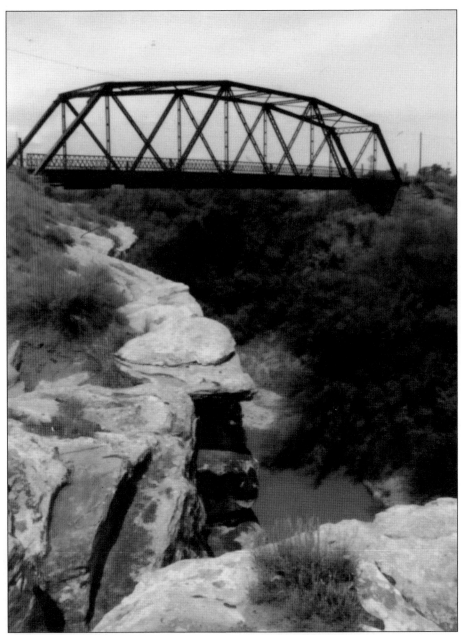

WOODRUFF-SNOWFLAKE BRIDGE, MOVED 1939. The Lyman Dam near St. Johns collapsed in 1915, wiping out nearly all of the bridges on the Little Colorado River between St. Johns and Winslow. Navajo County used bond funds to rebuild seven of the bridges, including the Winslow Bridge. This steel truss bridge was fabricated in Chicago, shipped by rail to Winslow, and erected over the Little Colorado River. About 20 years later, when it was decided to replace the Winslow Bridge because of its narrow width and wooden deck, the county relocated one of the truss spans to a local dirt road near the community of Woodruff (about 50 miles from the original location). Since 1939, it has spanned the Little Colorado River over this narrow and beautiful gorge. The trusses fit well at this location with minor modifications. Navajo County is in the process of rehabilitating it to further prolong its life.

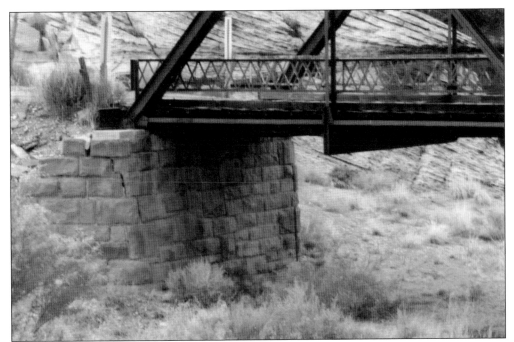

ABUTMENT WALLS, WOODRUFF-SNOWFLAKE BRIDGE. These walls were built using the red sandstone that lines the Little Colorado gorge. This is the same material used in the impressive Woodruff Dam, where Silver Creek joins the Little Colorado River. The sandstone walls have deteriorated and cracked. The cracks in the wall will be repaired, and the wooden deck will be replaced with a concrete deck.

WOODRUFF DAM, BUILT 1919. The Mormon community of Woodruff, established in 1877, was continually flooded by the Little Colorado River and Silver Creek. Dams were constructed with local labor at least 12 times before this one held. The Woodruff-Snowflake Bridge is to the left of the dam, beyond the frame of this photograph.

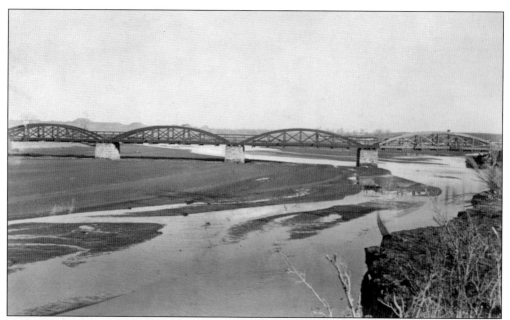

HOLBROOK BRIDGE, 1896. Spanning the Little Colorado River just south of Holbrook on State Route 77, this bridge provided an important link between Route 66 and the town of Snowflake. Shown here is the multi-span timber bowstring truss bridge. Several other iterations of this bridge were constructed without the use of wood before a girder structure was built in 1991. (Northern Arizona University, Cline Library.)

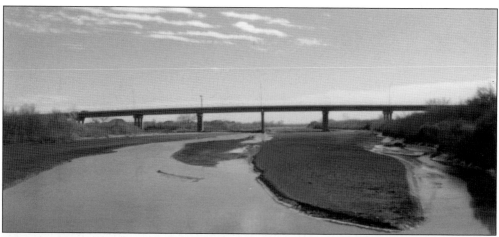

HOLBROOK BRIDGE, BUILT 1991. The modern, concrete-girder version of this bridge has 17 spans and is 1,728 feet long and 62 feet wide. As with most of the historic bridges profiled in this book, the older bridges were too short to handle the ever-changing widths of the river following flood events, and it could not handle the increasing traffic volumes and loads.

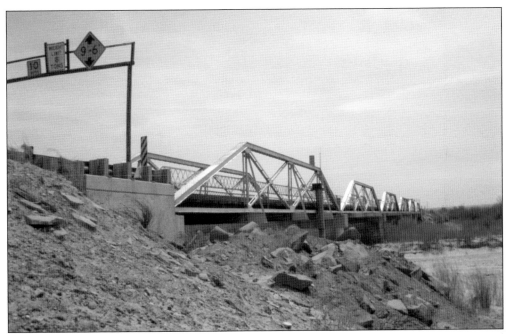

OBED ROAD BRIDGE, BUILT 1917. This bridge spans the Little Colorado River at Joseph City and was one of seven rebuilt after the 1915 Lyman Dam failure near St. Johns. It was a link between Route 66 and Territorial Road (parallel to Route 66). The bridge was 500 feet long and had an eight-ton weight limit, so Navajo County decided to replace it to accommodate larger loads. (Navajo County.)

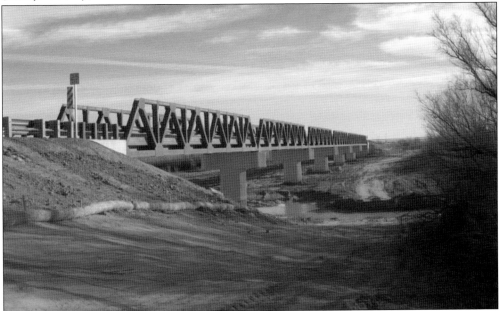

OBED ROAD BRIDGE, REBUILT 2011. The historic six-span steel Pratt pony truss structure was replaced with one similar in appearance to the historic bridge. This design method was also used on the Hereford Road Bridge in southern Arizona. Both use new, stronger steel trusses on existing abutments. While they now hold 40-ton loads, they remain one-lane bridges. (Navajo County.)

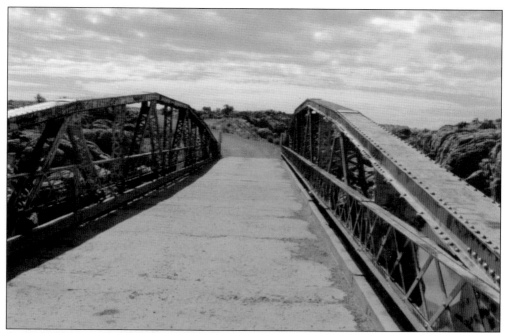

CHEVELON CREEK BRIDGE, BUILT 1913. This bridge is located about 12 miles southeast of Winslow on Territorial Road, off State Route 99. There is debate about whether this Warren truss bridge ever carried Route 66 traffic. Some claim that Route 66 ran north of the Little Colorado River, while others say it was south of the river. This photograph was taken prior to its rehabilitation by Navajo County in 2014.

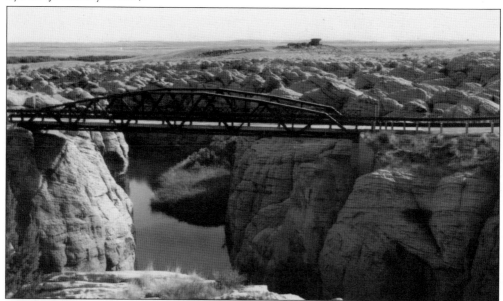

CHEVELON CREEK BRIDGE, REHABILITATED 2014. As part of the recent rehabilitation, Navajo County replaced the deteriorating concrete deck, repaired the damaged steel members, and lowered the bridge deck, which slightly changed the original proportions of the bridge. The county also repainted the trusses a shiny black. These efforts will greatly prolong the life of this beautiful historic structure, located on a visually stunning portion of the creek. (John Gleason.)

FREDERICK HENRY HARVEY (1835–1901).
Harvey, an innovative marketer, built hotels and restaurants all along the Atchison, Topeka & Santa Fe train routes and throughout the West. The comforts of the time were provided in an expeditious manner: decent food, a shave, a bath, a clean bed, and souvenirs. "Fast food" became associated with him and his well-disciplined, mostly female staff. (Wikimedia Commons.)

HARVEY GIRLS. Fred Harvey recruited these women, generally between 18 and 30 years old, from the Midwest, where he had his headquarters. They sought adventure and independence but had to agree to the strict rules imposed on them by the propriety of the time and by Harvey. Financial freedom helped these women and raised the bar for the burgeoning hospitality industry in the West. (Wikimedia Commons.)

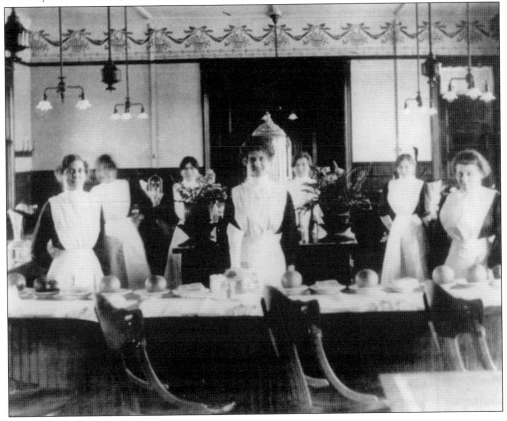

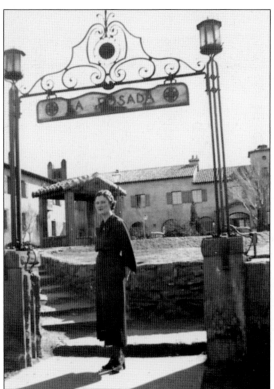

LA POSADA HOTEL, BUILT 1930. This hotel in Winslow was fairly typical of Fred Harvey's style. He collaborated with the famous architect Mary Colter (1869–1958) in the building's design and that of the furnishings. This vintage photograph shows one of Harvey's employees welcoming guests. Unfortunately, like many of the glorious railroad hotels, it closed in 1958 and was converted into offices for the railroad. It has since been reopened as a hotel. (Wikimedia Commons.)

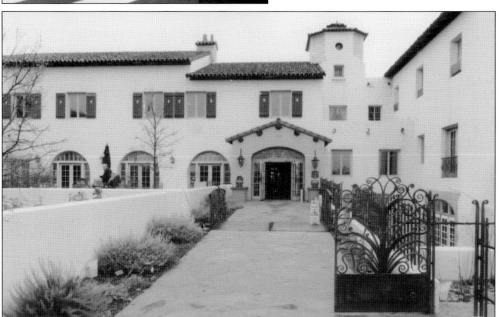

LA POSADA HOTEL, WINSLOW. This building was proposed for demolition a number of times. It was purchased in 1997, and ongoing renovation continues, as is the case with most labors of love involving older buildings and bridges. It now welcomes guests for nightly stays, dinner, and cocktails. The hotel has its own art gallery and game room, and the outside gardens have also been brought back to life by the new owners.

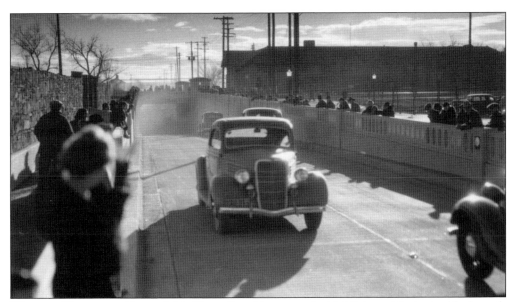

WINSLOW UNDERPASS, BUILT 1936. The railroad intersected with Highway 87, about a block south of Route 66 in Winslow. The underpass was funded through New Deal legislation sponsored by Carl Hayden. It was designed and built during the Great Depression. This vintage photograph was taken during the dedication of the underpass. (Arizona Department of Transportation.)

WINSLOW UNDERPASS TODAY. The underpass is a concrete structure designed in the Mission style, with decoratively pierced walls and a tiled-roof tower. It is located adjacent to the historic La Posada Hotel. The underpass remains in use today, ferrying traffic under the railroad on a low-volume state highway.

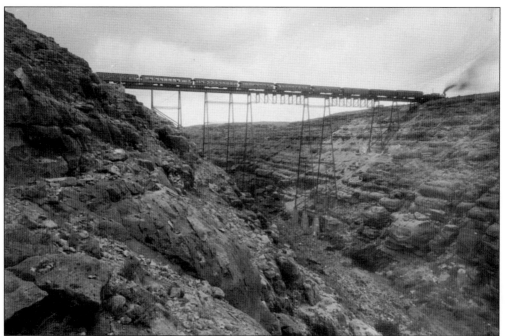

CANYON DIABLO RAILROAD BRIDGE, BUILT 1882. Not far from the future Route 66, the railroad was laying track across northern Arizona at a lightning pace when workers encountered this major canyon. The route could not be changed to a narrower section of the canyon. Several attempts were made to span the canyon, which caused major delays and allowed the lawless town of Diablo to spring up to serve the idle workers. (Wikimedia Commons.)

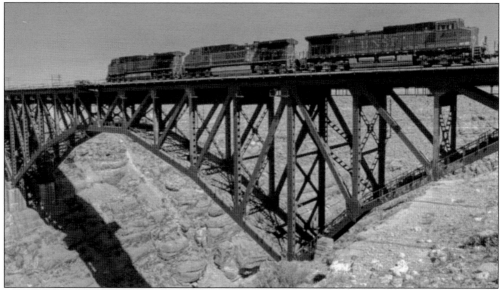

MODERNIZED CANYON DIABLO RAILROAD BRIDGE. The wooden trestles of the original Canyon Diablo Bridge were replaced with several iterations before a steel arch was finally used in 1957 as the support for modern, heavier loads. Today, the Burlington Northern Santa Fe Railroad uses this bridge. It is located about four miles north of the Interstate 40–Two Guns interchange, on a rough, four-wheel-drive road. (John Gleason.)

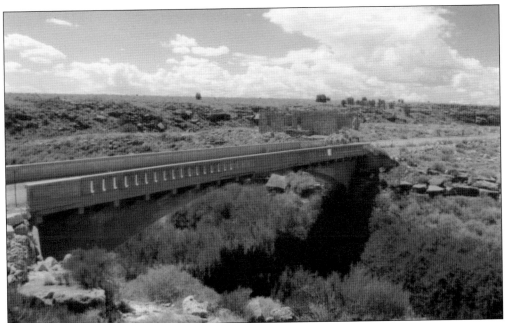

CANYON DIABLO BRIDGE, BUILT 1915. The railroad crossed this same canyon, but the road bridge took an easier path than did the span for the boxcars. This Route 66 bridge is south of the railroad and just south of Interstate 40, near Two Guns. It is a 128-foot-long span with a reinforced concrete Luten arch structure. It was abandoned in 1930.

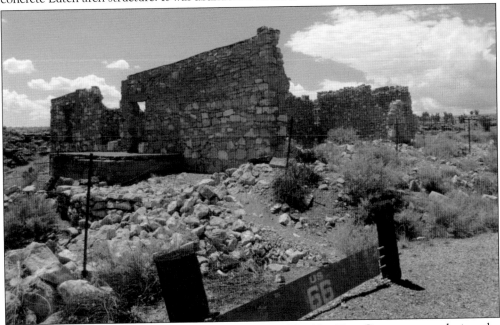

TOWN OF TWO GUNS, 1903. Similar to the town of Diablo, Two Guns grew up during the construction activity associated with Route 66 and the bridges. The town was named after a notorious, well-armed inhabitant who probably kept many potential settlers away. These are some of the substantial ruins, including the abandoned Canyon Diablo Bridge, left behind in this ghost town situated south of Interstate 40.

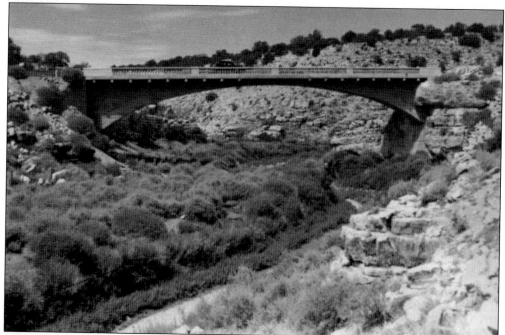

CANYON PADRE BRIDGE, BUILT 1914. This span had a decorative rail barrier, as did most bridges designed by Daniel Luten. The arch sprang from the concrete abutments and featured his trademark elliptical profile. Luten built roughly 4,000 bridges in the United States but lost his patent rights in a complex legal case that lasted years. The Luten arch design was favored because it allowed for longer spans. (Arizona Department of Transportation.)

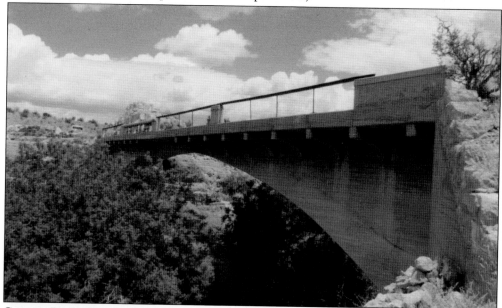

CANYON PADRE BRIDGE TODAY. As seen here, the decorative barriers have not survived, but the rest of the bridge is intact. It carried Route 66 traffic until 1937, when it was abandoned. It is located on a private dirt road north of Interstate 40, not far from the Twin Arrows interchange and a new Navajo casino.

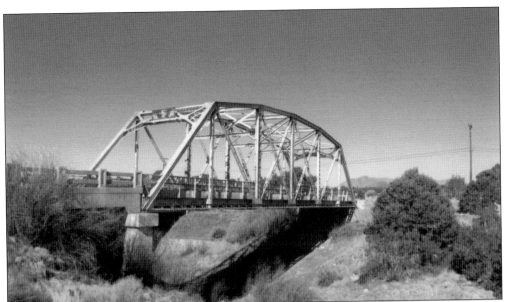

WALNUT CANYON/WINONA BRIDGE, BUILT 1924. The bridge is a single-span Parker steel through truss. It crosses Walnut Canyon near Winona, about eight miles east of Flagstaff and north of Interstate 40. Engineers with the Bureau of Public Roads designed the bridge using federal funds. The bridge later became part of Route 66.

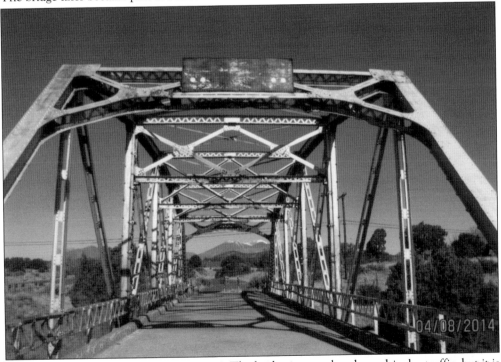

WALNUT CANYON/WINONA BRIDGE, 2014. The bridge is now closed to vehicular traffic, but it is easily accessible to pedestrians. It was replaced with a wider, concrete bridge when the roadway was realigned parallel to the old one. The snowcapped San Francisco Peaks, sacred to the Navajo, Hopi, and other Indian tribes, are framed by the steel truss members of the bridge.

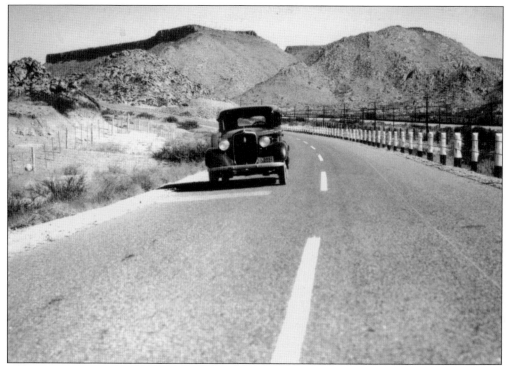

ROUTE 66 IN 1936. This photograph of the famous highway near Valentine shows part of the longest unbroken stretch of Route 66 still in use today. This 158-mile stretch begins west of Ash Fork and ends at Topock at the California border. (Arizona Department of Transportation.)

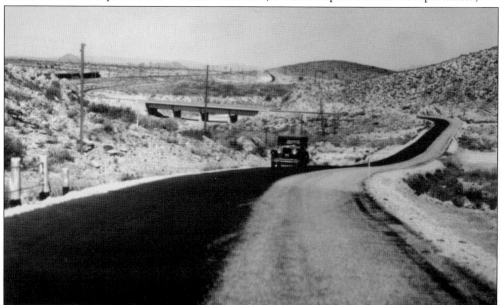

ROUTE 66 IN 1934. The roadway, seen here near Hackberry, is also part of the longest unbroken stretch of Route 66. The road, which remains much the same today as it did in 1934, is a relaxing way to travel between Ashford and Kingman. The bridge in this photograph spans Hackberry Wash. (Arizona Department of Transportation.)

OLD TRAILS WASH BRIDGE, BUILT 1918. This small bridge looks like a modern box culvert, but it reflects the standard 1918 design methods used by the Arizona Department of Transportation. The two-span concrete superstructure was reinforced with recycled railroad rails embedded in the concrete. This technique and material are no longer used, but they worked well for this structure.

OLD TRAILS WASH BRIDGE TODAY. This is the last historic bridge before the Colorado River. It helped to define historic Route 66 on its way to California. It now carries local residential traffic south of Interstate 40 on Old Trails Road.

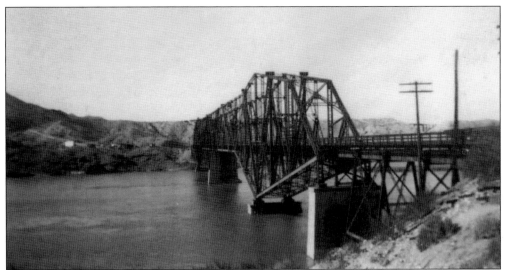

RED ROCK RAILROAD BRIDGE, BUILT 1890. Before the railroad bridge was built over the Colorado River, rope ferries transported everything crossing the river. With the advent of the automobile, and because of the slowness and unpredictability of ferry transportation, this railroad bridge was used by Route 66 automobile traffic, alternating with trains. (Arizona Department of Transportation.)

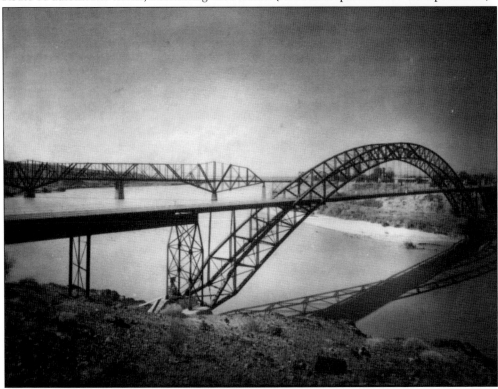

OLD TRAILS BRIDGE, BUILT 1916. The Old Trails Bridge (foreground) was built specifically for automobiles. In 1947, it was considered obsolete and converted into a carrier for utility lines. This elegant bridge is the last remaining historic bridge on Route 66 going west from Topock, Arizona, into California. (Arizona Department of Transportation.)

Two

US ROUTE 80

In the 1840s, the westward expansion of the United States was in full swing. Tensions with Mexico were heating up, as Texas had already declared independence. Pres. James K. Polk sent politician John Slidell to Mexico City in 1845 to buy New Mexico and California, but Mexico would have nothing of it. In 1846, the United States declared war on Mexico. Arizona was not seen as a prize, but it was a strategic transportation route. At this time, the Mormons, known as the Latter-day Saints, were looking to go farther west to less-populated areas. A company of men volunteered for military duty to prove their patriotism and to see what new lands they might occupy. Capt. Philip St. George Cooke led the Mormon Battalion from Santa Fe toward San Diego. Their route took them through the southeastern part of Arizona, up the San Pedro River to the Gila River and west to Yuma and California. The only shots fired during this military expedition were at some wild cattle that attacked the battalion near the San Pedro River. This first route through southern Arizona would later be modified to meet the all-weather transportation mandates established by the US Congress after the war with Mexico.

The Ocean-to-Ocean Highway through the southern half of the United States was one of the mandated roadways. It entered Arizona at Springerville in the middle of the state and dipped into Phoenix and west to Yuma. US Route 80, also known as the Borderland Highway, went south from New Mexico into Douglas before heading north through Bisbee, Tombstone, Tucson, and Florence. Mining and military operations were important to this route variation. In the early 1900s, Bisbee, "Queen of the Copper Camps," was the most populous city in Arizona. Douglas had the copper smelter, and Fort Huachuca Army Base was 25 miles away.

The bridges profiled here begin in Douglas and end at Yuma. Some are associated with both US Route 80 and the Ocean-to-Ocean Highway routes.

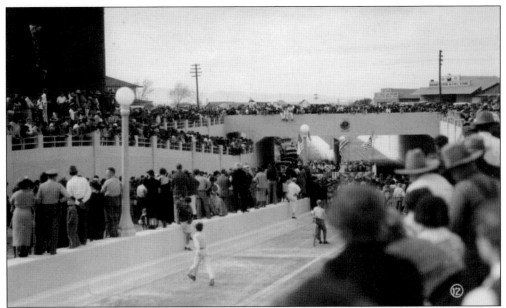

Douglas Underpass, Built 1936. The Borderland Highway (US Route 80) entered Arizona at Rodeo, New Mexico, and continued to Douglas. Before the construction of this underpass, 20 trains a day rumbled through the middle of town. This photograph depicts the opening of the underpass and the joy it created with residents. After the mines closed in the 1970s, the railroad was abandoned, and the underpass was later demolished. (Arizona Department of Transportation.)

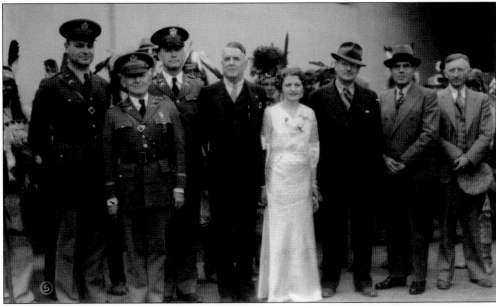

Douglas Underpass Dedication, 1936. Shown here are, from left to right in the first row, three soldiers from Fort Huachuca Army Base, Dr. Shaw (owner of Cochise Stronghold), Dorothy Decker (Douglas High School student), G.W. Hoopman (chairman of the Arizona Highway Commission), Jack A. Casson (contractor), and Ralph Hoffman (state bridge engineer). Standing behind them are Apache Indians representing former chief Cochise, for whom the county is named. (Mary Lou Vaughan.)

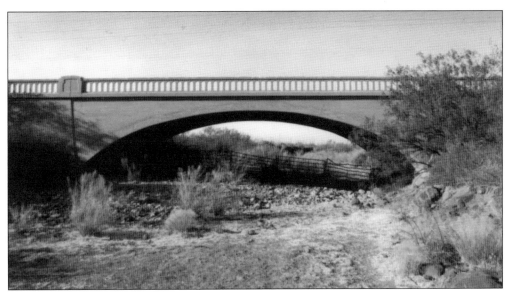

LOWELL ARCH BRIDGE, BUILT 1911. The first remaining historic road bridge on US Route 80 is one of the oldest in Arizona. This reinforced concrete-filled spandrel arch bridge spans the Mule Gulch Wash east of Bisbee. The elliptical arch springs gracefully from the concrete abutments, which can only be appreciated from below. These washes near the international border are passageways for people wanting to avoid the US Border Patrol checkpoints.

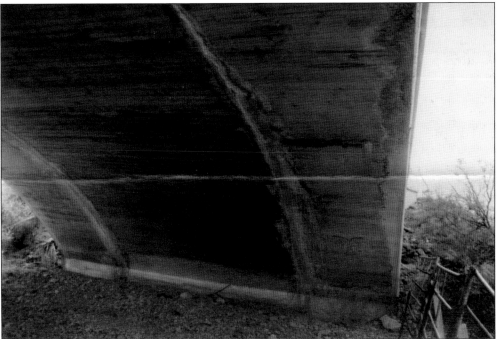

LOWELL ARCH BRIDGE WIDENED. Designed by J.B. Girand, the official engineer of the Arizona Territory, this bridge was narrow and could not accommodate traffic associated with Phelps Dodge mining activities between the Douglas smelter and Bisbee mines. In 1934, the width was increased to 30 feet, and the decorative concrete barriers with incised panels were replaced to match Girand's original design.

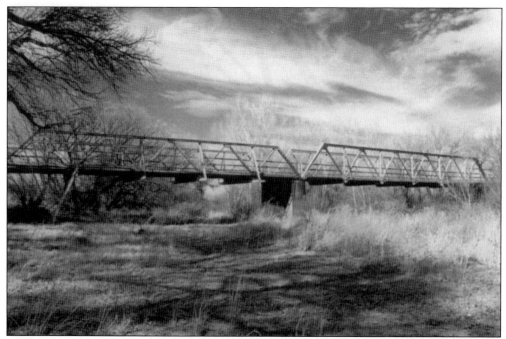

HEREFORD ROAD BRIDGE, BUILT 1913, 1915, AND 1927. This bridge was built in three phases and is located in the heart of the San Pedro River Riparian National Conservation Area and near a former home of Col. William Cornell Greene, a founder of mines in southern Arizona and Mexico. The bridge provided a connection between the mining towns, Fort Huachuca Army Base, and the growing community that would become known as Sierra Vista.

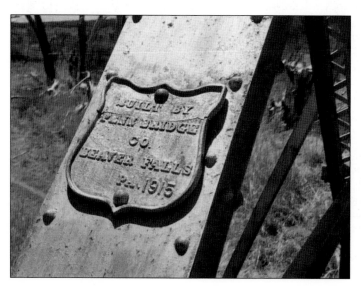

HEREFORD ROAD BRIDGE PLAQUE. The Penn Bridge Company, a major fabricator of short trusses, provided many local governments with standard-length steel trusses. However, the lengths of the spans were often not long enough and the abutments not deep enough to handle the scouring rampage of floodwaters. As a result, a section would often fail and have to be replaced, as with this bridge.

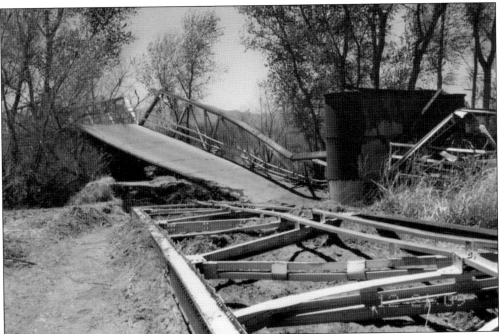

HEREFORD BRIDGE COLLAPSE. The bridge posted a maximum weight limit of 15 tons. Cochise County officials were in the process of applying for federal rehabilitation funds when a fully loaded concrete truck drove over the bridge twice. In April 2003, the bridge collapsed, and the truck dropped into the river, crushing an endangered plant. The driver was unhurt, but he lost his job. (Cochise County.)

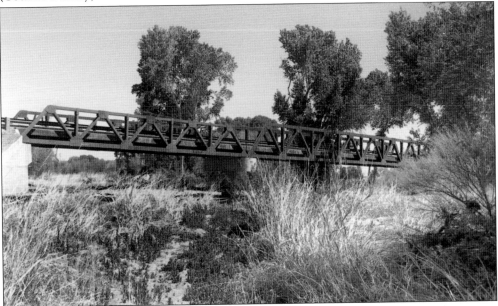

HEREFORD BRIDGE, 2006. In rebuilding the bridge, Cochise County decided to utilize the existing abutments and to mirror the one-lane width and steel truss pattern of the historic one. The three weathered steel trusses were fabricated in Ohio, shipped in, and placed on new piers. The bridge is now strong enough to handle modern loads.

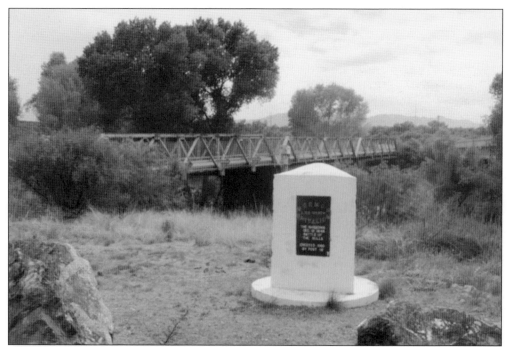

CHARLESTON ROAD BRIDGE AND PLAQUE. North of the Hereford Bridge on the San Pedro River are the two Charleston bridges. The historical bridge, now abandoned, is seen here behind a plaque that describes the Mormon Battalion's 1846 encounter with a wild herd of bulls. The bullets fired at those aggressive cattle would be the only ones used in the battalion's 2,000-mile journey from Iowa to California. (Cochise County.)

CHARLESTON ROAD BRIDGE, BUILT 1917. Fencing barricades have been installed to keep people from walking on the historic structure. There is the potential for this bridge to be opened up and made into a pedestrian/cycling path in this rare riparian ecosystem known for its diversity of migratory birds. Cochise County used federal funds to build a new concrete girder bridge next to this one. (Cochise County.)

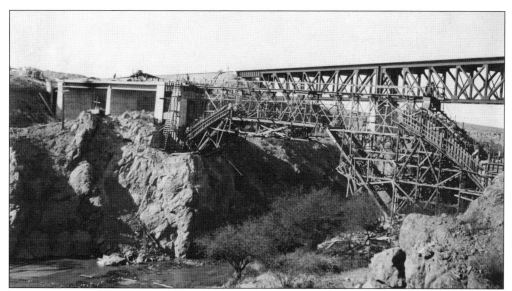

CIENEGA CREEK BRIDGE, BUILT 1921. This vintage photograph shows the construction of the road bridge over the creek. The contractor used temporary falsework to support the wet concrete. In the background is the multi-span steel Southern Pacific Railroad bridge. The Cienega Creek Bridge is one of Arizona's more historically significant vehicular structures, designed by state bridge engineer Ralph Hoffman. (Arizona Historical Society.)

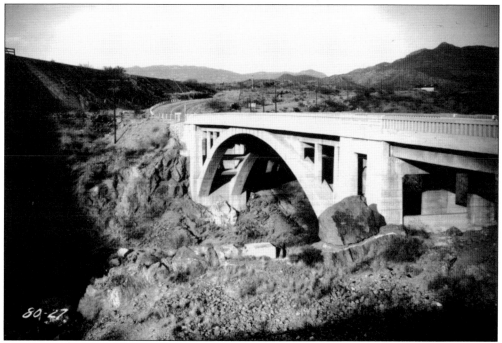

CIENEGA CREEK BRIDGE, 1930s. This reinforced-concrete open-spandrel arch spans 146 feet over the creek. The bridge carried US Route 80 until Interstate 10 was built. This substantial structure today looks almost the same as in this photograph. The barrier rails have been replaced, but in a historically sensitive manner. It is located on Marsh Station Road, south of Tucson. (Arizona Department of Transportation.)

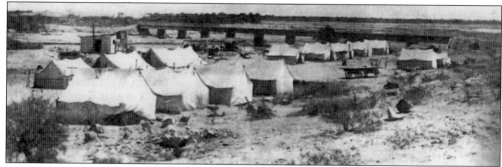

FLORENCE BRIDGE, BUILT 1910. Convicts were used as part of a successful experiment to reduce construction costs. As an inducement for satisfactory performance, for every day worked, two days would be deducted from a prisoner's term. This photograph shows the convict camp near the bridge site over the Gila River, near Florence. J.B. Girand, Arizona territorial engineer, designed this multi-span concrete girder bridge. (Arizona Department of Transportation.)

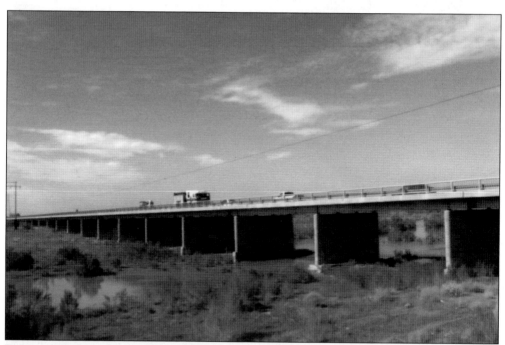

FLORENCE BRIDGE, BUILT 1957. The river continued to wash away the approaches to the 1917 bridge, isolating it to the middle of the channel. More repairs were made to this isolated structure than to any other bridge. Finally, in the 1950s, the Arizona Department of Transportation replaced the concrete bridge with a steel girder bridge. At one time, US Route 80 went through Florence, but today, the bridge carries State Route 79 over the Gila River.

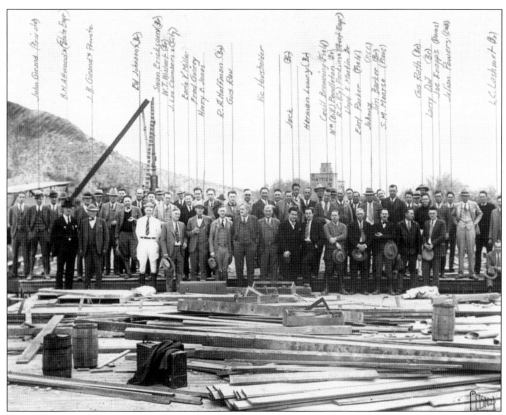

The photograph contains the following handwritten name labels: John Girand (Bear oily), B.M. Atwood (State Engr), J.B. Girand's Private, Ed Johnson (Br), Swan Erickson (Br), W.T. Wisener (Br), J. Lee Chambers x Cty, Earle F. Miller, Fred Givey, Henry A. Jones, R.R. Hoffman (Br), Gus Kau, Vic Householder, Jack (Br), Herman Lowry (Br), Cecil Benning (Fied), Wm (Bill) Pendleton (Br), R.C. (Cy) Perkins (Roof Engr), Lloyd E. Martin Jr, Earl Parker (Field), Johnny (R.C.C.), Jim Barker (Br), S.M. Moorse (Plans), Gus Reith (Br), Larry Dal' (Br), Joe Knopps (Plans), Julian Powers (Cub), L.C. Lashmet (Br)

MILL AVENUE BRIDGE SITE, 1928. Ralph Hoffman, near the middle in the first row, designed this bridge, and he was clearly pleased that many of his esteemed colleagues showed up for this event. This vintage photograph, from his own collection, includes familiar figures such as B.M. Atwood (state engineer) and J.B. Girand (territorial engineer). Girand designed the Ash Avenue Bridge. (Mary Lou Vaughan.)

ASH AVENUE BRIDGE, BUILT 1913. This was one of the first bridges designed by J.B. Girand. The Ash Avenue Bridge, the center bridge in this photograph, was built over the wide Salt River by convict laborers. The bridge had 11 concrete arch spans, each 125 feet. It replaced Hayden's Ferry as a crossing of the river. It was removed in 1990, except for a small span that has been creatively incorporated into a park.

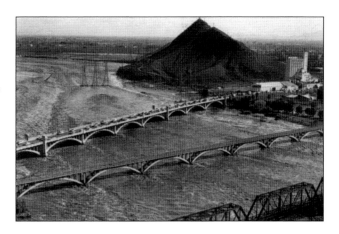

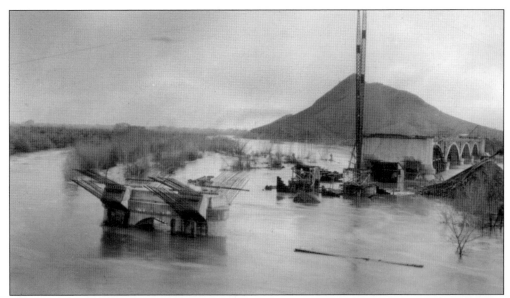

MILL AVENUE BRIDGE, BUILT 1931. In 1928, Tempe businessmen convinced the Arizona Highway Commission that the 18-foot-wide Ash Avenue Bridge was an impediment to traffic and that they needed a wider bridge. Ralph Hoffman designed a 10-span concrete, open-spandrel structure. This photograph, taken during construction, shows the impact of seasonal rains. (Arizona Department of Transportation.)

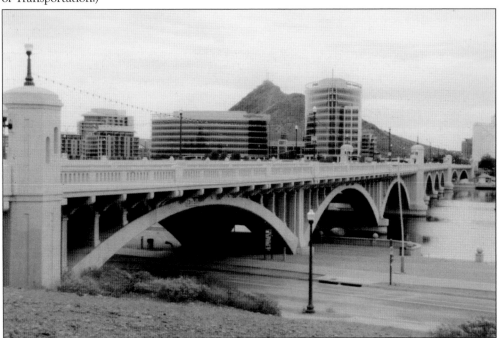

MILL AVENUE BRIDGE OVER TOWN LAKE. A parallel bridge was built upriver from the 1931 bridge to handle traffic over the Salt River. The bridge carried US Route 80 as part of the Ocean-to-Ocean Highway as well as US Route 89 and US Route 60. It now carries Mill Avenue over the Tempe Town Lake, a focal point of the city of Tempe's revitalization. The Mill Avenue Bridge has decorative details, which enhance its appearance.

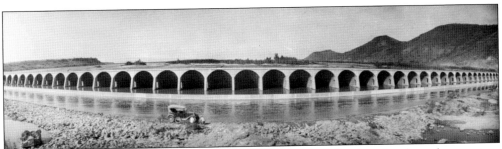

GILLESPIE DAM, BUILT 1921. The dam was built by Frank Gillespie, a local rancher, to store water from the Gila River for agricultural purposes. J.B. Girand designed the dam while he was in private practice. He had previously served as Arizona's territorial engineer. (Arizona Department of Transportation.)

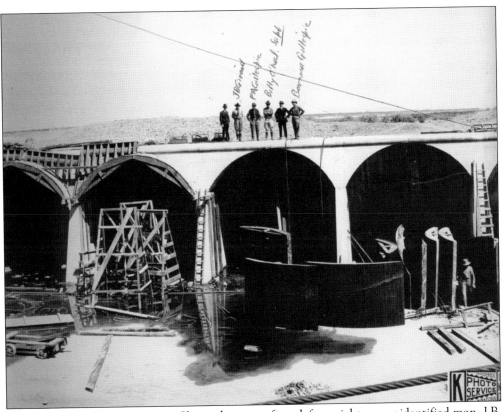

GILLESPIE DAM CONSTRUCTION. Shown here are, from left to right, an unidentified man, J.B. Girand, Frank Gillespie, Billy O'Neil, an unidentified man, and Bernard Gillespie. Most of the structures in this era were designed by government agencies, so it was rare when a project's engineer was from a private firm and a property owner took on the expense. The firm founded by Girand would become one of the most respected in Arizona. (Arizona State Archives.)

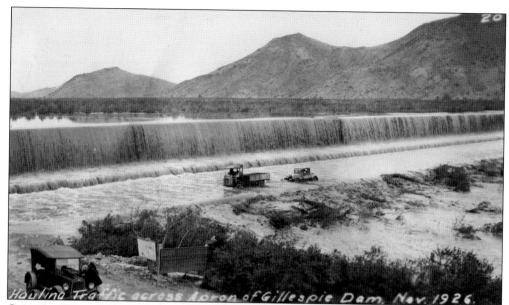

GILLESPIE DAM, 1926. Vehicles take a chance traveling along the concrete apron in front of the dam as water flows over it. In 1927, when Gillespie Dam Bridge was completed, cars and trucks traveling on US Route 80 highway could avoid being washed downstream. (Arizona State Archives.)

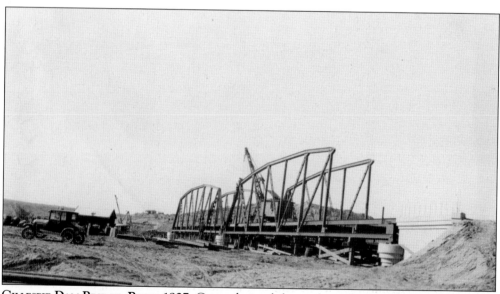

GILLESPIE DAM BRIDGE, BUILT 1927. Cranes hoisted the steel members in place, and they were then riveted together, forming camelback trusses. The bridge was designed by Ralph Hoffman using through trusses, which put the mass of the structure above the roadway. This tended to obscure the views of the river from the bridge. (Arizona State Archives.)

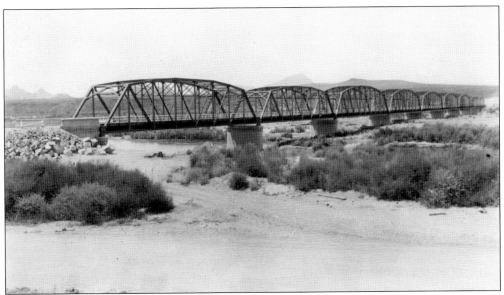

GILLESPIE DAM BRIDGE. Crossing the wide Gila River required a nine-span bridge over 1,662 feet in length. It carried traffic on the Ocean-to-Ocean Highway (US Route 80) until 1956, when the highway was realigned. The bridge, now owned by Maricopa County, is located near Arlington. (Arizona State Archives.)

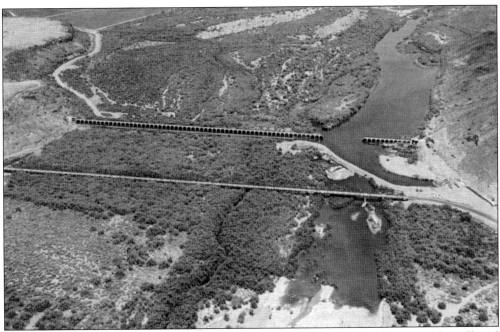

GILLESPIE DAM BREACHED, 1993. The dam was the victim of a major flooding event that affected many parts of Arizona. When the dam failed, water rushed toward the bridge, causing settlement of several piers. The bridge was rehabilitated in 2012, and the pier footings were stabilized to prevent further damage. This photograph shows how wide and unpredictable the ever-changing Gila River watershed can be. (Richard Strange.)

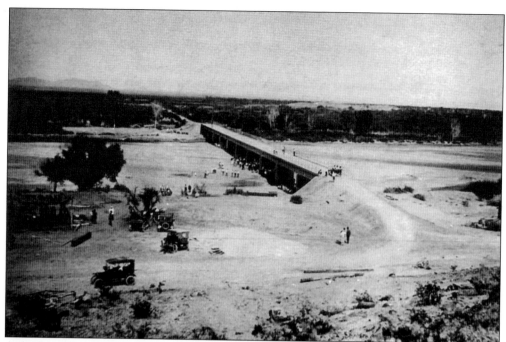

ANTELOPE HILL BRIDGE, BUILT 1915. This bridge over the Gila River was an integral part of the Ocean-to-Ocean Highway. Designed by Lamar Cobb, Arizona's first state engineer, it was a 1,000-foot-long multi-span reinforced girder bridge with timber trestles on each side. The 1915 dedication ceremony shown here was attended by Gov. George Hunt and many others. (Arizona Historical Society, Yuma Collection.)

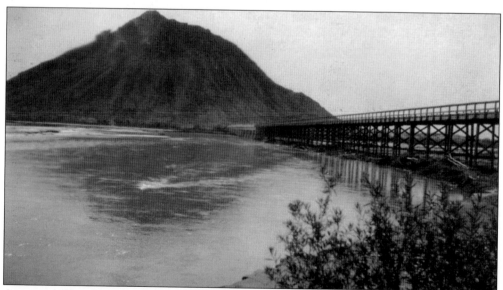

ANTELOPE HILL BRIDGE, 1922. With some water in the Gila River, the span is still in good condition. This did not last, as flooding of the river caused repeated damage due to scouring of the foundation. This possibility was not foreseen by the engineers who designed the bridge. (Arizona Department of Transportation.)

GILA RIVER CROSSINGS. The location of the Antelope Hill Bridge was always problematic due to constant flooding. This vintage photograph shows some alternatives for crossing the river. Repairs were made to the bridge, but more damage occurred. It was finally replaced with the McPhaul Bridge. Several spans of the original bridge remain, but it is abandoned. (Arizona Department of Transportation.)

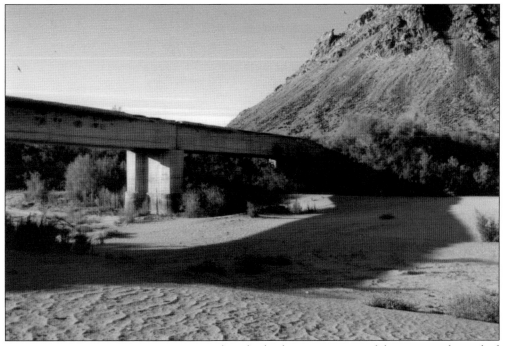

ANTELOPE HILL BRIDGE REMNANTS. Today, the bridge is in a state of disrepair, with cracked concrete, exposed reinforced steel, and several spans washed away. This was a two-girder bridge, similar to the Santa Cruz River Bridge near Nogales, built around the same time. The remnants are located north of Interstate 8, at the foot of Antelope Hill, four miles from Tacna.

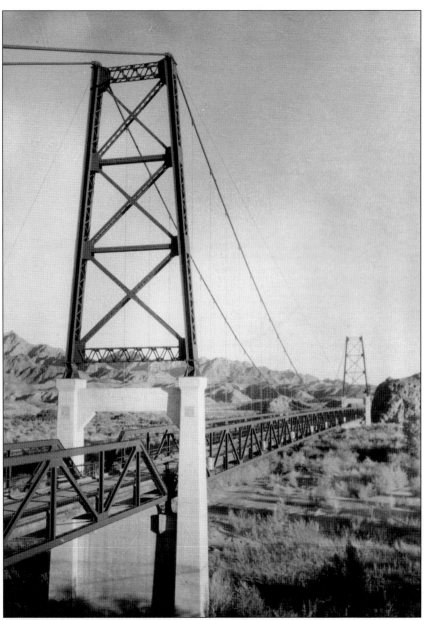

McPhaul Bridge, Built 1929. Sometimes known as the "Dome Bridge," this span replaced the Antelope Hill Bridge, located about 30 miles east. There was an existing ford located here, and the new bridge replaced that service. The Arizona Department of Transportation hired renowned engineer Ralph Modjeski to design it. He had a lot of experience designing long-span bridges. The new location was chosen for the granite rock on both sides, which could serve as anchors for the suspension bridge. McPhaul Bridge carried traffic until it was replaced in 1968 and was closed. It is ironic that after the bridge was closed, a flood on the Gila River in 1993 washed out a newer bridge upriver, carrying US Route 95 traffic. The McPhaul Bridge remained intact. Strikingly beautiful, graceful, and exotic for its time, this bridge is historically and technologically relevant and is among Arizona's most important, but threatened, bridges. (Arizona Department of Transportation.)

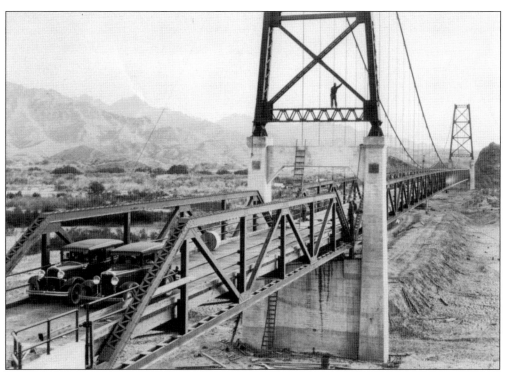

McPhaul Bridge Construction, 1929. The bridge was named after Harry McPhaul, Yuma County sheriff and the only county resident to be an Arizona Ranger. He was also a prospector who, during the construction of the foundations, panned for gold from the excavated materials, hoping that the bridge was sitting on a gold supply. Following these efforts, he was nicknamed "Hard Rock Harry." (Arizona Historical Society.)

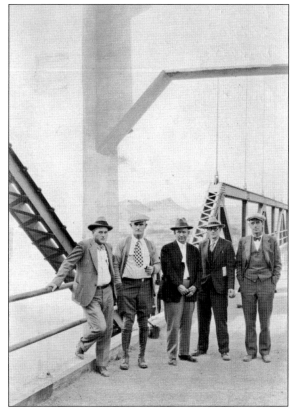

McPhaul Bridge Opening, 1929. Posing here from left to right are ? Fowman (a member of the board of supervisors), ? Ellison (county engineer), ? Downey (chairman of the board of supervisors), ? Sawyer (city engineer), and Dale Ralston (assistant county engineer). Ralston located the site of the bridge. (Arizona Historical Society.)

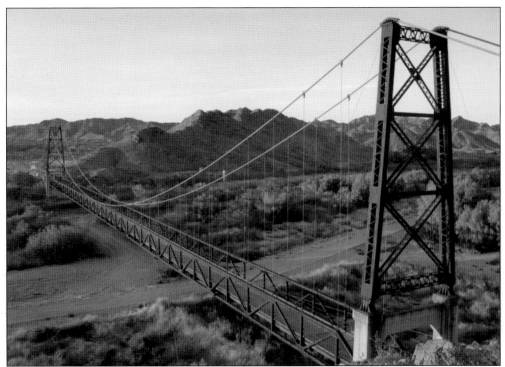

McPhaul Bridge. The McPhaul Bridge (pictured) and the Cameron Bridge on US Route 89 are the only vehicular suspension bridges in Arizona. The McPhaul Bridge's main span is 798 feet long, for a total bridge length of 1,184 feet. It was designed by Ralph Modjeski, a preeminent American engineer who also designed the Huey P. Long Bridge in New Orleans and the San Francisco–Oakland Bay Bridge. (Wikimedia Commons.)

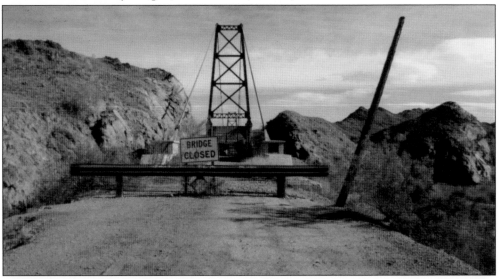

McPhaul Bridge Today. The bridge is currently closed to the public, and repairs to the wooden deck are needed. The bridge span was the longest in Arizona at the time it was built. The elegant structure still has the potential of being revived as a pedestrian, multiuse path, which would increase tourism. The bridge is located north of Interstate 8 at Dome near Yuma.

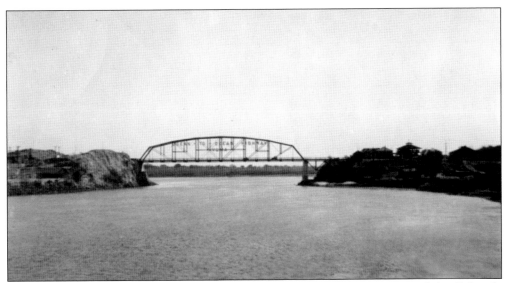

OCEAN-TO-OCEAN HIGHWAY BRIDGE, BUILT 1915. Rock outcroppings narrowed the Colorado River to 450 feet. It was here that this bridge was located. This vintage photograph shows the Pennsylvania through trusses and the lighted "Ocean-to-Ocean" sign. It was a crucial link of US Route 80, spanning the river at the Yuma Crossing and connecting the Atlantic Ocean with the Pacific Ocean. (Arizona Historical Society, Yuma Collection.)

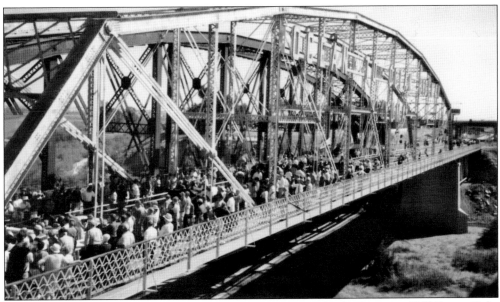

OCEAN-TO-OCEAN HIGHWAY BRIDGE REDEDICATION, 2002. This bridge carried US Route 80 for decades until Interstate 8 was built. Due to concerns about structural integrity, the bridge was closed in 1988. Yuma County rehabilitated and reopened it in 2002 for pedestrian traffic and alternating one-way vehicular traffic using a signal at each end of the bridge. The illuminated sign was also rebuilt.

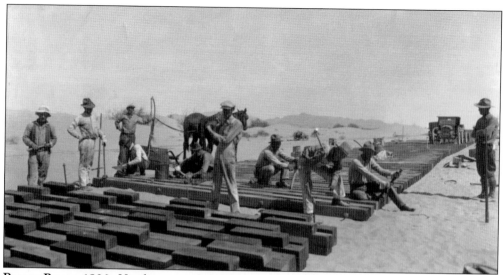

PLANK ROAD, 1920. Heading west from Yuma and into California on US Route 80, it was necessary to travel over the sand dunes. This photograph shows construction workers installing wooden planks for the roadway, which kept vehicles from getting stuck in the sand. (Arizona Department of Transportation.)

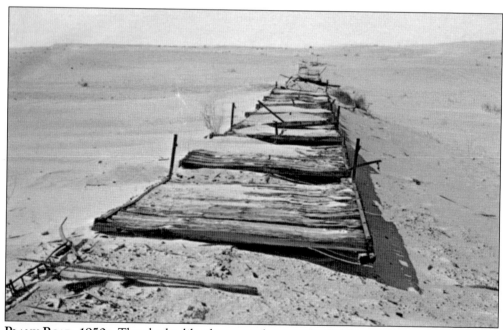

PLANK ROAD, 1950s. The planks, like those seen here on the California side, were built mainly for the new automobiles, but they quickly deteriorated with the weather and shifting sand. The old road and new Interstate 8 followed the paths taken by Juan Bautista de Anza in the late 1700s and the Mormon Battalion and Butterfield Stage in the 1800s. (Merle Porter and Royal Pictures.)

Three

Colorado River

The Colorado River runs 1,450 miles—from the Rocky Mountains in northern Colorado, two miles above sea level, to the Gulf of California. It drains parts of seven US states and two Mexican states. Many parts of the river were easily traveled by boat, but the Grand Canyon was another story. It took the hardy soul and body of John Wesley Powell (1834–1902), a veteran who lost an arm in the Civil War, and his fellow sailors to accomplish the very dangerous journey down the narrow canyon, thereby cementing the fact that freight travel along the entire river was not feasible.

Ferry crossings were created along the narrow, calmer sections, with the Yuma Crossing being the most significant and the site of an Army outpost. Steamboat service, which began in the 1850s, was cheaper than carrying freight over land. Large sea ships would travel from San Francisco, around Baja California, to the mouth of the Colorado River. Small steamboats, which could more easily navigate in the shallow waters, would take cargo upriver to Yuma.

In 1858, when Lt. Edward Beale was coming to the final legs of his survey of the 35th parallel, the camels would not swim across the river, so a steamboat was eventually used to transport them, providing a very odd sight. When the railroad arrived at Yuma in 1877, a pivot span was utilized in the construction of the bridge in order to allow the boats to pass. Riverboat business began a gradual decline, finally ending in 1907, when the Laguna Dam was built above Yuma.

Today, the natural beauty and ecological and historical sites along the river and its tributaries are much changed from the days of Powell. The river system is one of the most heavily developed, controlled, and litigated in the world, with 15 dams on the main stem of the Colorado River and hundreds more on tributaries. It currently supplies over 40 million people with water. The journey in this chapter starts in Yuma, continues north to the Grand Canyon, and ends at Page.

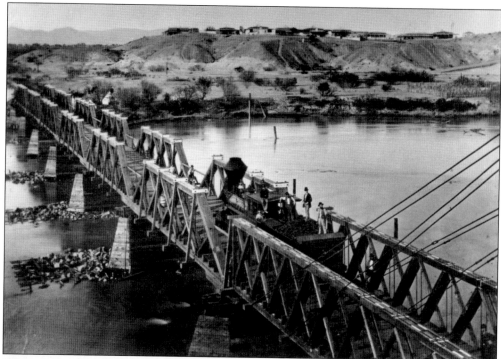

WOODEN RAILROAD SWING BRIDGE, BUILT 1877. The first bridge across the Colorado River was open to traffic when regular train service was inaugurated in Yuma on September 30, 1877. The bridge was a six-span wooden truss structure built on the current Madison Street alignment. (Arizona Historical Society, Yuma Collection.)

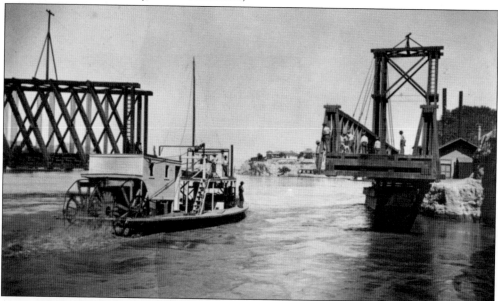

SWING BRIDGE OVER COLORADO RIVER. In 1877, steamboat travel was still very much in play, so accommodation had to be made to allow their passage, as shown here. One of the wooden spans swung off a concrete pier pivot for the passage of steamboats. It was then closed to allow the passage of trains. (Arizona Historical Society, Yuma Collection.)

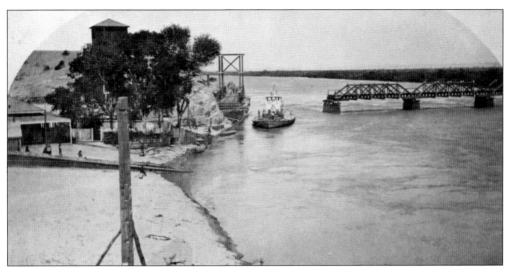

WOODEN RAILROAD SWING BRIDGE. A steamboat passes through the open swing span. Wooden bridges were economical to build, but they were prone to fires and were not able to withstand constant flooding. The railroads finally chose steel as the preferred material, and a new bridge with a pivot was built in 1895. (Arizona Historical Society, Yuma Collection.)

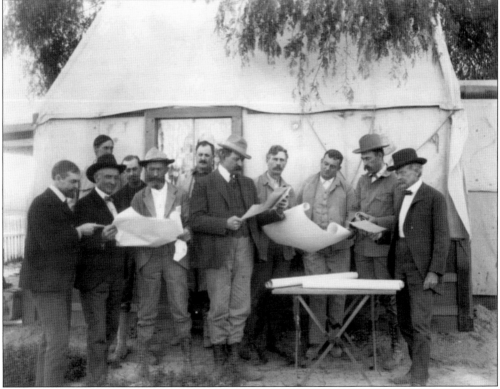

YUMA BOARD OF ENGINEERS, 1904. This gathering includes members from agencies such as the US Bureau of Reclamation, the Boundary Commission, and the Yuma County Water Users Association. Members shown are, in unknown order, ? Hall, ? Sanders, ? Means, ? Quintin, ? Hamlin, ? Savage, ? Davis, ? Perkins, ? Lippincott, and ? Wisner. (Library of Congress.)

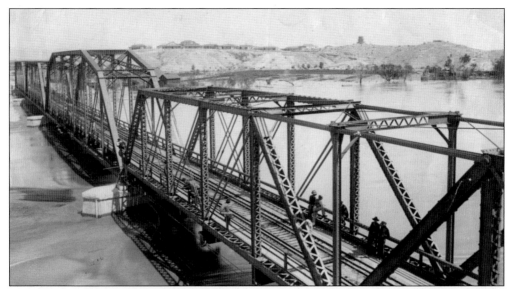

STEEL RAILROAD BRIDGE, BUILT 1895. This vintage photograph shows the steel bridge in a closed position. The swing span, technically known as a counterbalanced draw span, was inefficient because of the time it took for the span to be moved back and forth and for the slow-moving boats to get through. There are no more of these in Arizona. (Arizona Historical Society, Yuma Collection.)

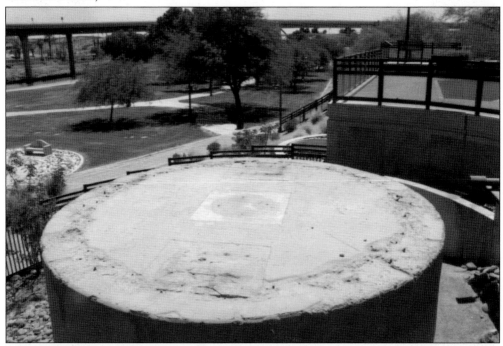

PIVOT POINT, BUILT 1895. Recent archeological investigations unearthed the circular concrete pier, with the 1895 date etched into it. This pivot point replaced an earlier one and was used to support the railroad bridge swing span, which allowed riverboats to pass. It is located at the end of Madison Street and has been incorporated into a park created along the river. Interstate 8 bridge is shown in the background.

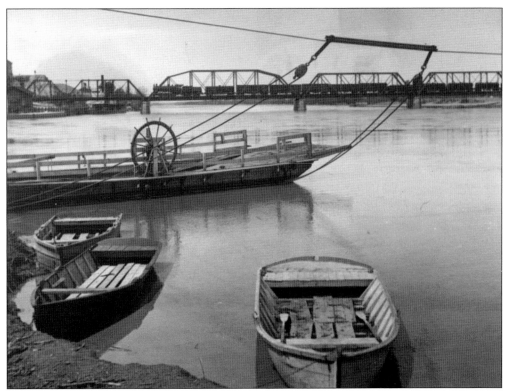

ROPE FERRY. This ferry is shown upriver from the railroad bridge that no longer exists. Rope ferries were used for everyday crossings of the river before the Ocean-to-Ocean Highway Bridge was built in 1915. After the passage of the Reclamation Act in 1902, construction began on the Laguna Dam (1903–1909) north of Yuma. Riverboat service ceased on most of the river. (Library of Congress.)

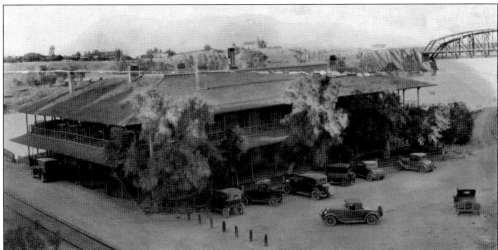

SOUTHERN PACIFIC RAILROAD HOTEL, YUMA. This photograph shows the unique building and automobile styles of the 1920s. The bridges on the right are the Ocean-to-Ocean Highway Bridge and the 1924 railroad bridge, still in existence today. The hotel no longer exists. (Arizona Historical Society, Yuma Collection.)

CARL HAYDEN, C. 1916. Hayden was born in 1877 at Hayden's Ferry, renamed Tempe in 1878, where his father had a freight service on the Salt River. His career in politics started when he was attending Stanford University. In Arizona, Hayden was elected to Congress in 1911 and went to Washington, DC, on the same day that President Taft signed legislation granting Arizona statehood. Hayden served 56 years in the US House and Senate, quietly wielding his influence, especially as it related to reclamation and other public-works projects. He obtained federal funding for the Ocean-to-Ocean and historic Navajo Bridges and was instrumental in the creation of the federal highway system and the Central Arizona Project. He died in 1972. (Library of Congress.)

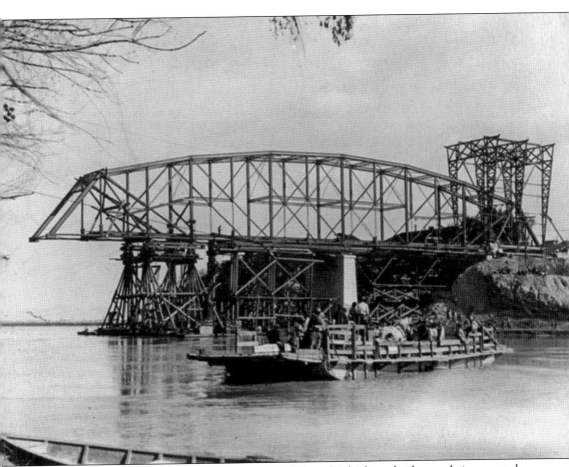

OCEAN-TO-OCEAN HIGHWAY BRIDGE, BUILT 1915. When this highway bridge was being erected, the Colorado River and a tributary, the Gila River, were still powerful forces to contend with, even though the Laguna Dam had been built upriver. The bridge designer had never visited the site and used a design that required falsework in the river to support the bridge during construction. Twice, the falsework was washed out during seasonal floods. The contractor finally used barges floated into position to support the falsework during construction, and the bridge was completed. The bridge was Arizona's first highway bridge over the Colorado River. (Arizona Historical Society, Yuma Collection.)

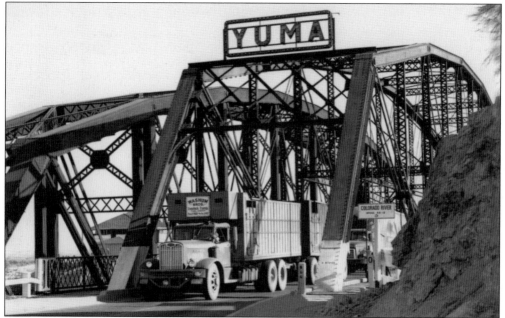

"Yuma." When the Ocean-to-Ocean Highway Bridge was built, it was the only highway bridge crossing the Colorado River for a distance of 1,000 miles. Soon after it was completed, citizens of Yuma erected large electrical signs on the bridge to publicize their progressive town. (Arizona Historical Society, Yuma Collection.)

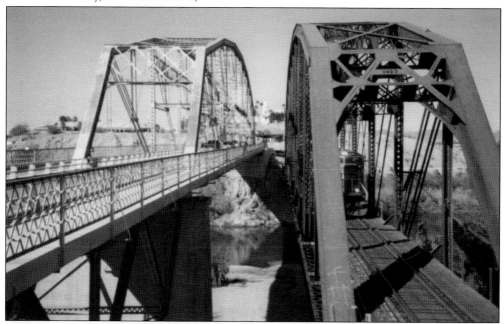

Railroad Bridge, Built 1924. The modern steel railroad bridge on the right was built after the highway bridge, although at least three versions preceded this one. The bridges are located on Penitentiary Avenue alignment, just yards from the Yuma Territorial Prison State Historic Park. Union Pacific, owner of the railroad, claims this bridge is one of the worst choke points in the nation. The company is studying its expansion.

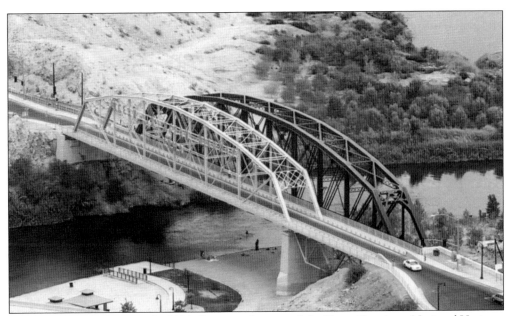

Colorado River Bridges. In 2000, Congress designated the Yuma Crossing a National Heritage Area, the second such designation west of the Mississippi River. In 2002, Yuma County completed a major rehabilitation of the Ocean-to-Ocean Highway Bridge (left), prolonging the life of this vital and historic link among Arizona, California, and the Quechan Indian Tribe. Later, the park and Pivot Point Plaza were built. The 1924 railroad bridge is on the right.

Yuma Crossing. This modern photograph of the historic Yuma Crossing looks downriver toward Mexico. The narrowing of the river, formed by two massive rock outcroppings, can be seen where two closely spaced steel truss bridges span the river (foreground). The curved bridge in the center is Interstate 8 over the river. (Library of Congress.)

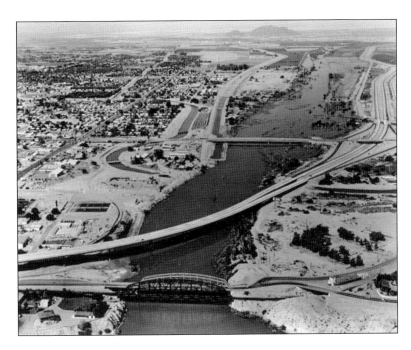

59

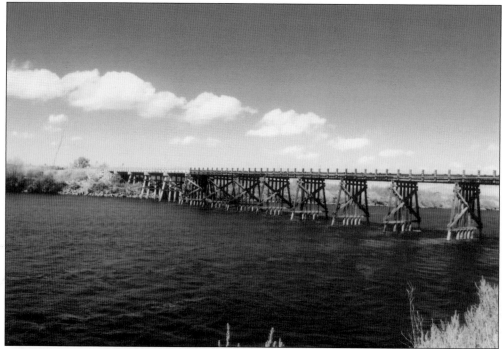

OXBOW BRIDGE, BUILT 1967. The Bureau of Reclamation built the Oxbow Bridge but later turned it over to La Paz County. It originally had 19 spans, one of which was removable to allow boats to pass. After a fire in 1995, the bridge was rebuilt without a removable span. At 567 feet, it is Arizona's longest wooden trestle bridge. It is located in a rich riparian and farming area.

OXBOW BRIDGE, 1995. The bridge was rehabilitated in 2012, with a new wooden deck replacing a deteriorated surface. The span, called the Oxbow Bridge for the nearby bend in the river, is located about 25 miles south of Blythe, California. (La Paz County.)

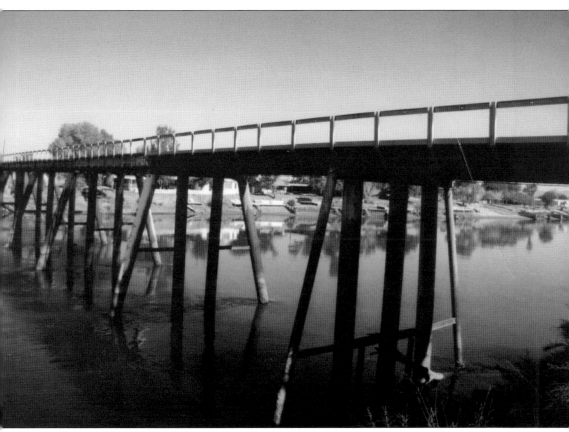

CIBOLA BRIDGE. The Cibola Valley, north of Yuma and south of Ehrenberg, is a rich agricultural area and wildlife habitat. It is where the river would overflow, thereby providing fertile farmland. However, the flows were sporadic; either a flood or a drought would wipe out the crops. Once the dams were built and the river was controlled, this would change. Irrigation districts were formed to determine how and when water would be delivered, and the land is now a year-round producer of crops on the Arizona and California sides. In order to transport crops to and from both sides, the Cibola Bridge was built in 1957. It was destroyed in 1976. The Farmers Bridge was built by a coalition of farmers in 1981 to replace the Cibola Bridge, and they named it after themselves. One of the spans is still removable to allow boats through, but it would require considerable effort to do so.

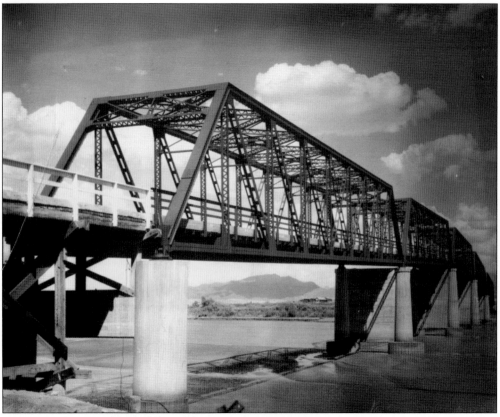

EHRENBERG BRIDGE, BUILT 1930S. This 1933 photograph shows the multi-span steel truss bridge over the Colorado River between Ehrenberg and Blythe, California. Before Interstate 10 was built, this bridge carried traffic over the river. The town of Ehrenberg was named after Herman Ehrenberg (1816–1866), a surveyor, adventurer, and soldier who fought against Mexico in the Texas Revolution. (Arizona Department of Transportation.)

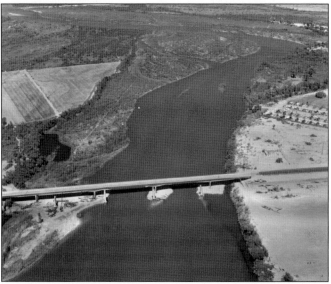

EHRENBERG BRIDGE OVER COLORADO RIVER, BUILT 1961. This multi-span steel girder bridge was built by the California Department of Transportation. Located between Blythe, California, and Ehrenberg, it carries Interstate 10 over the Colorado River at Ehrenberg. It replaced a multi-span steel truss bridge. This vintage photograph shows the width of the river during low flows. (California Department of Transportation.)

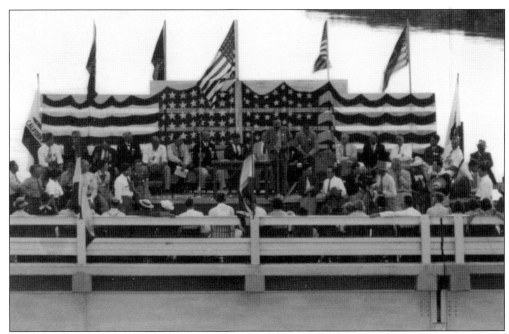

PARKER BRIDGE, BUILT 1937. The dedication platform was placed on the bridge for this event. The Colorado River can be seen in the background, behind the American flag. The Arizona and California flags are on either end of the platform. (Arizona State Archives.)

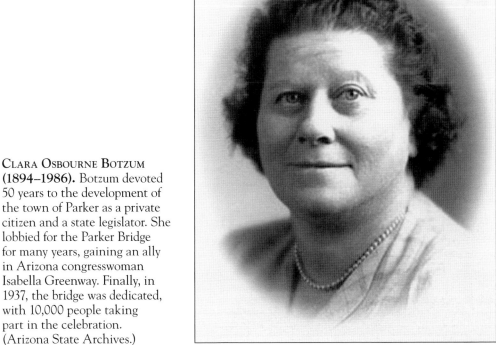

CLARA OSBOURNE BOTZUM (1894–1986). Botzum devoted 50 years to the development of the town of Parker as a private citizen and a state legislator. She lobbied for the Parker Bridge for many years, gaining an ally in Arizona congresswoman Isabella Greenway. Finally, in 1937, the bridge was dedicated, with 10,000 people taking part in the celebration. (Arizona State Archives.)

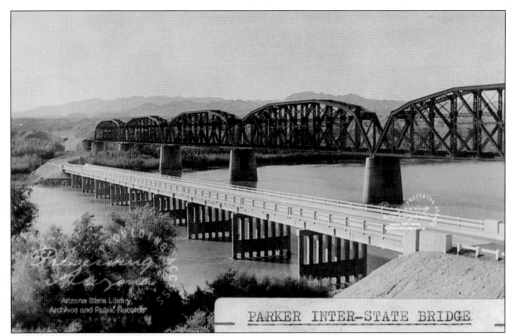

SANTA FE RAILROAD BRIDGE, BUILT 1908. At the time it was built, this bridge at Parker was considered one of the finest railroad bridges in the west. This steel truss bridge (right) spans the Colorado River, connecting Arizona and California. The 1937 vehicle bridge (left) was replaced by a new bridge in 2014. (Arizona State Library, Archives and Public Records, History and Archives Division, Phoenix.)

CLARA OSBOURNE BOTZUM BRIDGE, BUILT 2014. This multi-span cast-in-place concrete girder bridge at Parker replaced the 1937 vehicle bridge. This attractive bridge was designed by the California Department of Transportation. The engineer shaped the concrete in an artistic way, with elegant curves and a barrier railing that allow motorists a view of the river. A plaque in the middle of the bridge next to the sidewalk pays tribute to Clara Botzum.

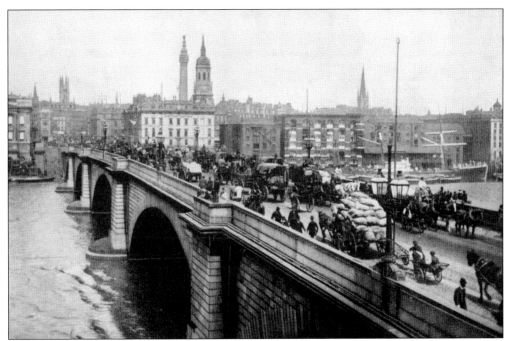

LONDON BRIDGE OVER THE THAMES RIVER, BUILT 1831. This span replaced the bridge built in 1209. John Rennie (1761–1821), already a famous engineer, used masonry arches in his design. He died during construction, so his son John finished it. The story of Rennie's death and the passing on of the project to another generation was similar to that of the Roeblings, who built the Brooklyn Bridge. (Old UK Photos.)

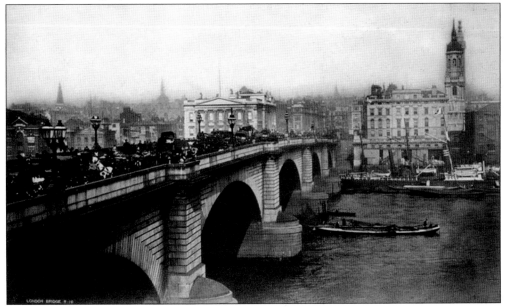

LONDON BRIDGE. This is one of the most famous bridges in the world, celebrated in literature, song, and theater. While it survived the air raids of two world wars, it needed to be replaced and was put up for sale by the city of London. Robert P. McCulloch (1911–1977), a businessman, purchased it in 1968 and had it moved to Lake Havasu City, Arizona. (Wikimedia Commons.)

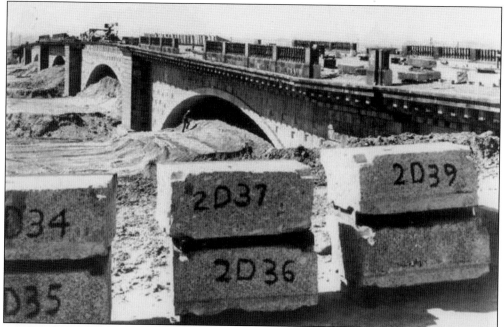

LONDON BRIDGE, LAKE HAVASU CITY, 1971. After the purchase of the London Bridge, each stone was identified as to its location before it was moved to Arizona and carefully repositioned on the new, reinforced concrete girder core. (Lake Havasu Museum of History.)

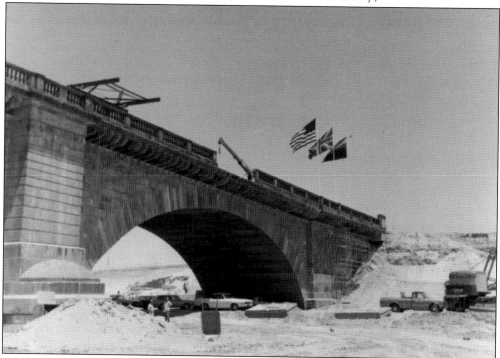

LONDON BRIDGE RECONSTRUCTION. It took three years to dismantle, ship, and reconstruct London Bridge in Lake Havasu. The job required 80 workmen, as compared to the 800 men who labored for seven years building the 1831 bridge. (Arizona Department of Transportation.)

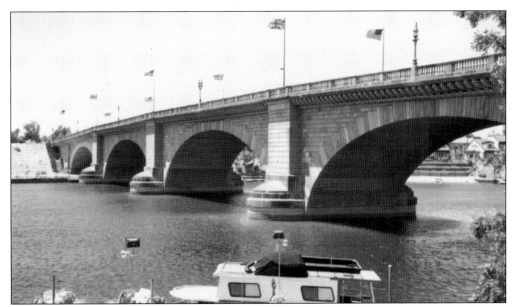

LONDON BRIDGE OVER THE COLORADO RIVER. The reconstructed bridge was dedicated in 1971. The channel was dredged out under the bridge, allowing the Colorado River to flow beneath it. This monumental task of removing, shipping, and rebuilding the bridge was a major engineering and logistics feat.

LONDON BRIDGE LAMPPOST. The lampposts on the new London Bridge had been on the original bridge in London. They were reportedly made from the cannons that Napoleon Bonaparte's army captured at Waterloo. They are ornately cast and have the green patina of aged metal. In 2006, the metal supports for the lampposts were replaced due to rusting at the metal supports, which caused the stone bases to crack.

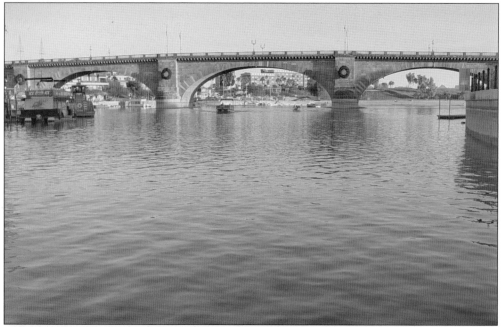

ARIZONA ATTRACTION. London Bridge is listed in the National Register of Historic Places, even though it originated in England. The bridge is Arizona's second-most-visited tourist attraction, after Grand Canyon National Park. Here, the bridge has been decorated for Christmas. Lake Havasu City takes great pride in the bridge and its history.

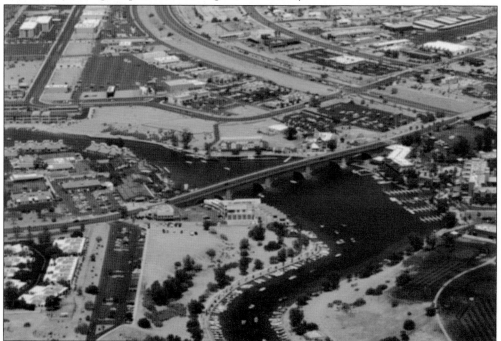

COLORADO RIVER CHANNEL, LAKE HAVASU CITY. After London Bridge was installed, the channel was dredged to create a lake under the bridge, leading to the larger Lake Havasu and the river. Londoners largely regret that their bridge left for America. (Wikimedia Commons.)

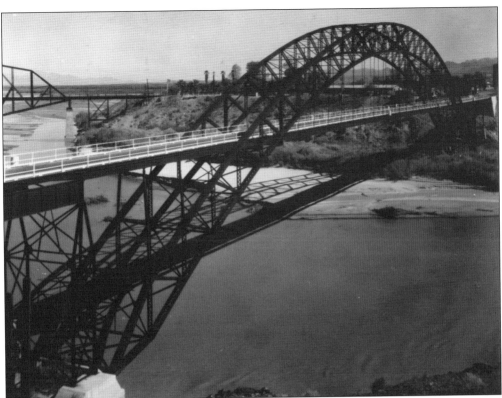

OLD TRAILS BRIDGE OVER THE COLORADO RIVER, BUILT 1916. The building of the Ocean-to-Ocean Highway Bridge in Yuma made the designers aware of the challenges of the Colorado River. They used their lessons to devise a cantilever system, in which the bridge halves were assembled on each riverbank. The halves were hoisted into place and connected mid-span over the river, rather than using falsework. (Arizona Department of Transportation.)

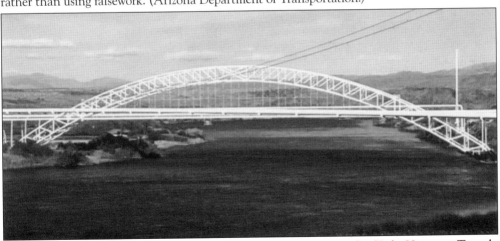

OLD TRAILS BRIDGE TODAY. The bridge spans the Colorado River north of Lake Havasu at Topock, near Needles, California, and has been repainted white. At its completion, the bridge was the longest arch bridge in America, and it remains a landmark of American civil engineering. It once carried Route 66 traffic but was eventually retired. It now carries a pipeline, rather than being converted to a pedestrian bridge and its tourist opportunities.

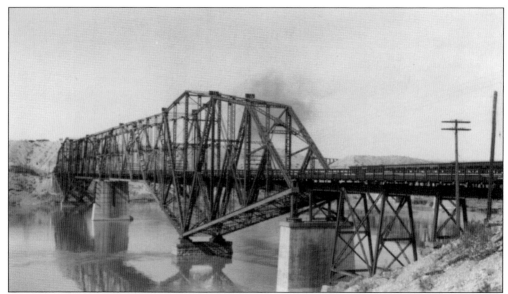

RED ROCK CANTILEVER BRIDGE OVER THE COLORADO RIVER, BUILT 1890. Before the Old Trails Bridge was built downriver, this one served first as a railroad bridge and then as a highway bridge. The unusual cantilever steel truss spans were designed by J.A.L. Waddell, a famous American engineer. It was the longest cantilevered span in the United States and is similar to the Forth Bridge in Scotland. (Courtesy of Arizona Department of Transportation.)

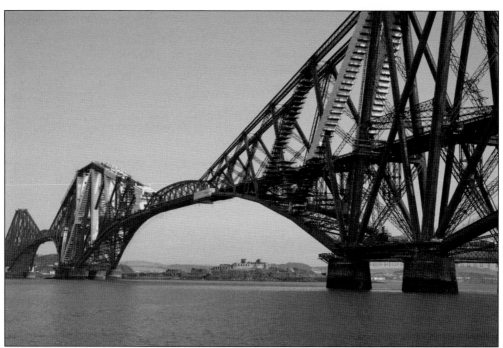

FORTH BRIDGE, BUILT 1890. This 2011 photograph shows the immensity of the structure in Firth of Forth, Scotland, compared to the one in Arizona. It was one of the first steel bridges built in Scotland and was the longest cantilever span in the world at that time. The island of Inchgarvie is in the background. (Wikimedia Commons.)

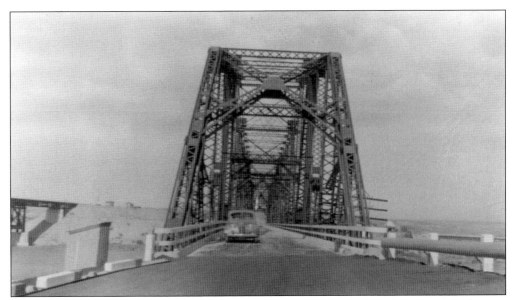

RED ROCK CANTILEVER BRIDGE. Ralph Hoffman converted the Red Rock Railroad Bridge to a highway bridge. It carried Route 66 traffic until it was removed in 1976. A new girder bridge was built for Interstate 40 over the Colorado River. (Arizona Department of Transportation.)

BRIDGE WORKERS, 1947. This vintage photograph shows workers on the Red Rock Cantilever Bridge, having completed converting the bridge to carry Route 66 traffic. The construction work was done by H.L. Royden, a Phoenix contractor, and included removing the train tracks, modifying the steel stringers, and providing a concrete roadway slab. (Arizona Department of Transportation.)

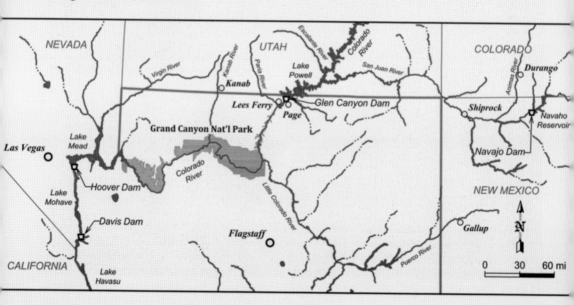

ext
Map by Terry Couchenour)

THE COLORADO RIVER IN NORTHERN ARIZONA. When Arizona became a state in 1912, the area north of the Colorado River to the Utah state line became known as the Arizona Strip, which was accessible only by ferryboat or by traveling through California or New Mexico. In 1929, after the Navajo Bridge was built near Lee's Ferry, US Route 89, the first north-south highway route, spanned the greatest of all natural barriers—the canyons of the Colorado River—thus providing easier access to travelers crossing the river. On the Colorado River, between Hoover Dam and Glen Canyon Dam, there are now four major highway bridges that each span between the steep canyon walls high above the river. Three of them are steel arches that each took two years to build, while the fourth (and most recent) bridge took five years to erect, due to the complexities of constructing a concrete arch bridge over the canyon. This chapter will continue profiling the four bridges, the two dams, and a few other bridges.

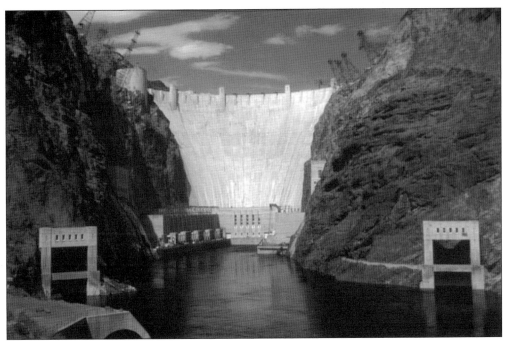

HOOVER DAM, BUILT 1935. The US Bureau of Reclamation devised plans for a massive dam on the Arizona-Nevada border to tame the Colorado River and provide water and power for the developing Southwest. Construction provided an immense challenge, and crews had to bore into carbon monoxide–choked tunnels and dangle from great heights. It was the largest dam in the world at the time and created Lake Mead, one of the biggest reservoirs in the country. (Richard Strange.)

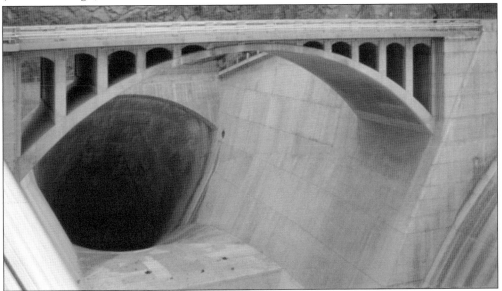

HOOVER DAM ARIZONA SPILLWAY BRIDGE, BUILT 1935. The bridge, with a span of 115 feet, is the shortest reinforced-concrete open-spandrel arch bridge in Arizona. It carried US Route 93 until 2010, when the Hoover Dam Bypass Bridge was built. The spillway consists of a tunnel blasted out of the rock wall of the dam to discharge overflow of the river across the dam. (Richard Strange.)

HOOVER DAM BRIDGES. This photograph shows the historic Hoover Dam Spillway Arch Bridge (left) and the concrete arch Hoover Dam Bypass Bridge carrying US Route 93. Hoover Dam was once the dominant feature, but the bypass bridge is much higher, overshadowing the dam.

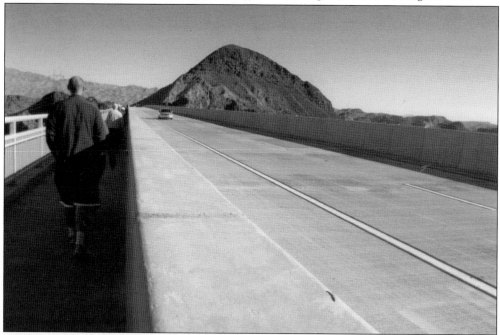

HOOVER DAM BYPASS BRIDGE. The pedestrian walkway on the bridge allows people to view the dam below. Motorists only see the tall concrete barrier wall and cannot take in the breathtaking view of Black Canyon and the Colorado River about 890 feet below.

CONSTRUCTION OF KAIBAB TRAIL BRIDGE IN THE GRAND CANYON, 1928. A mule pack train carries the structural steel cables for the bridge from the top of the canyon to the river. The eight suspension cables, each 550 feet long, were carried down on the shoulders of 42 men. Thus, each man carried 50 pounds of the cables. (National Park Service.)

KAIBAB TRAIL BRIDGES. The purpose of the Kaibab Bridge was to provide a continuation of the walking trail at the bottom of the Grand Canyon spanning the Colorado River The 1928 Kaibab Bridge replaced an older bridge, shown under the new one, that was later removed. The older one swayed so severely in strong winds, it would completely turn over. Even in moderate winds, it was a scary and hazardous crossing. (National Park Service.)

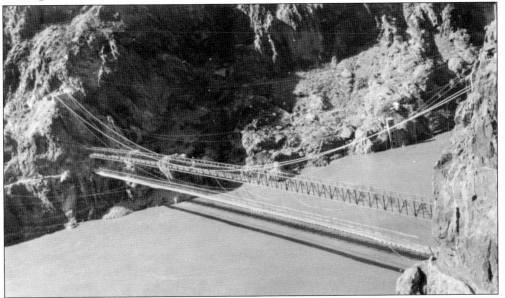

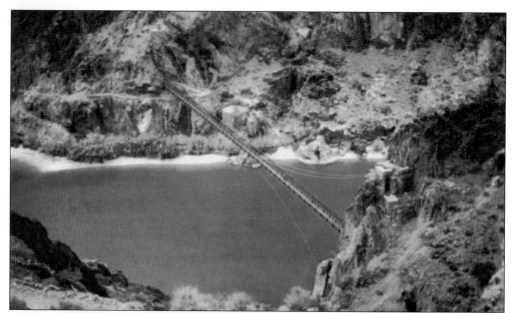

KAIBAB TRAIL BRIDGE, BUILT 1928. Before these trail bridges were built, an aerial trolley carried travelers across the river to Phantom Ranch. Teddy Roosevelt used it many times in his travels into the Grand Canyon. The aerial trolley remains for special use by the National Park Service. (Richard Strange.)

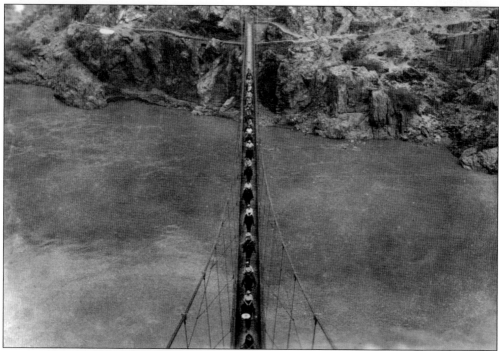

MULE TRAIN, 1930. Mules travel over the Kaibab Trail Bridge, carrying tourists across the Colorado River. A solid floor was used on the bridge to keep mules from viewing the river. In 1963, another bridge was built upstream, using helicopters. It serves as a backup to the Kaibab Bridge and carries a water line. (Sharlot Hall Museum.)

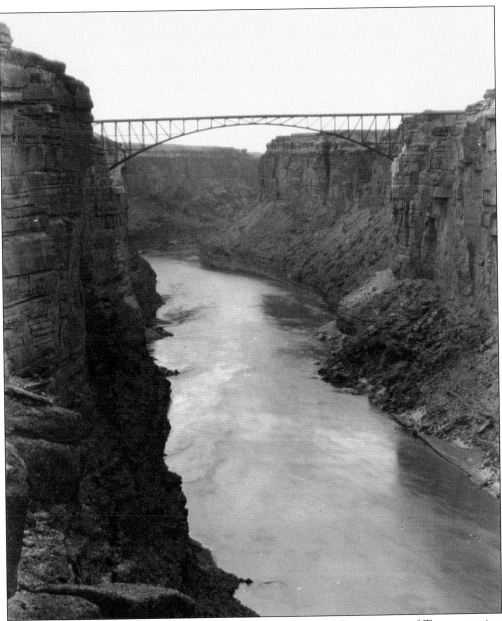

HISTORIC NAVAJO BRIDGE, BUILT 1929. In 1923, the Arizona Department of Transportation surveyed a road that would go from Flagstaff to Utah. The main obstacle was the crossing of the Colorado River at Marble Canyon. They considered a suspension bridge, like the one at Cameron, and then a through arch bridge, similar to the Old Trials Bridge at Topock. Ralph Hoffman, state bridge engineer, decided on a steel deck arch bridge. He thought it would be stronger and easier to build than the other two designs. Funding, as always, was a major consideration, but, with Congressman Carl Hayden working behind the scenes, federal and state funds were allocated. When it was built, this bridge was the only crossing of the Colorado River for 600 miles and opened up an area between Arizona and Utah known as the Arizona Strip. This was Ralph Hoffman's finest work of his long career. He designed it to fit into the natural beauty of the canyon, affording the traveler amazing views. (Northern Arizona University, Cline Library.)

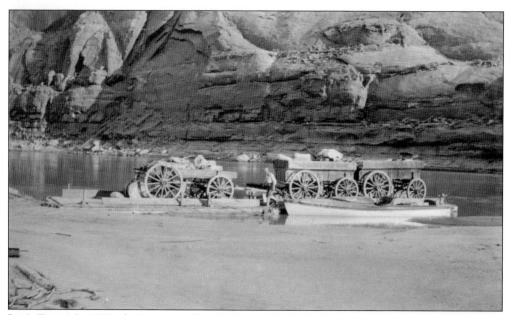

LEE'S FERRY. In 1872, the Mormon Church directed John D. Lee to operate the first commercial ferry service, to assist in the northern migration of people into Utah. The ferry provided only seasonal passage. In 1928, an out-of-control ferry crashed, killing three people. This accident, and the fact that the Navajo Bridge was being built, put an end to ferries. (Northern Arizona University, Cline Library.)

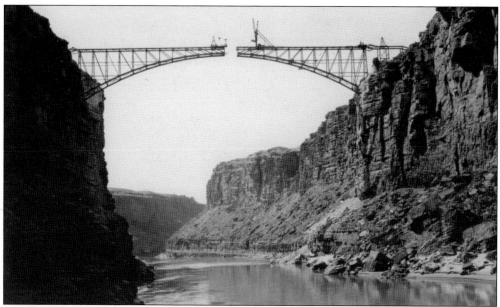

HISTORIC NAVAJO BRIDGE CONSTRUCTION, 1928. When the bridge was built, it was the highest highway bridge in the world. Special techniques were required to build it. The steel arch halves were cantilevered out from the canyon walls. With the bridge anchored to the rock, the two halves met at mid-span over the Colorado River. A steel pin was placed to join the bridge halves. (Arizona Department of Transportation.)

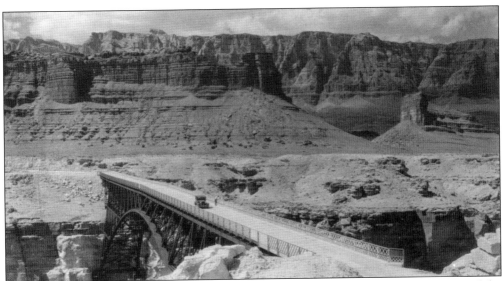

VIEW FROM THE BRIDGE. The stunning setting of the vertical red walls of Marble Canyon and the Vermilion Cliffs often caused traffic to stop on the Navajo Bridge, as motorists sought photographic opportunities or simply looked over the edge. As tourism and commerce increased, so did the need for a wider road. In the 1990s, the Arizona Department of Transportation decided to build a new bridge and convert the old one into a pedestrian span. (Northern Arizona University, Cline Library.)

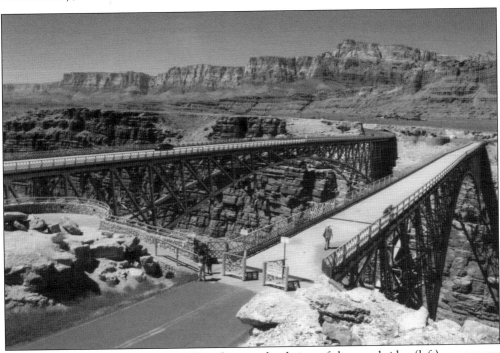

NEW NAVAJO BRIDGE, BUILT 1995. Deciding on the design of the new bridge (left) was a more complicated and inclusive process than had been common in Hoffman's time. A number of different designs were presented in meetings with the Navajo Nation, federal agencies, environmental groups, and local business owners. Finally, a design was chosen that closely mirrored Hoffman's.

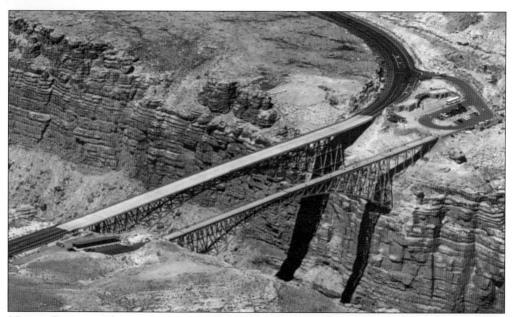

NAVAJO BRIDGES. The two bridges, parallel and at the same elevation, connect the Interpretive Center (top right) and the Navajo Sales area (bottom left). Once the location of the new bridge was decided, it allowed a space where the Navajo Indians could safely sell their goods. The sales area, built by the Navajo Nation, has proven to be so popular with the Navajo artists that a lottery system is used to determine seller positions.

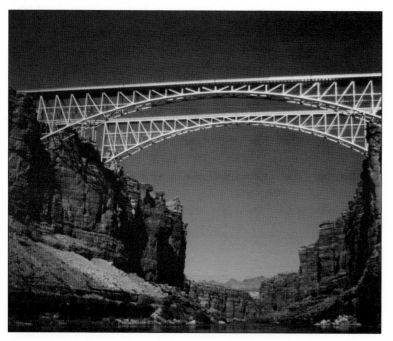

NAVAJO BRIDGES ABOVE THE COLORADO RIVER. This photograph more clearly shows how much the new bridge (foreground) matches the airy appearance of the older one. In this way, they compliment each other. They are approximately 467 feet above the river and are best seen from a boat in order to fully appreciate the aesthetics.

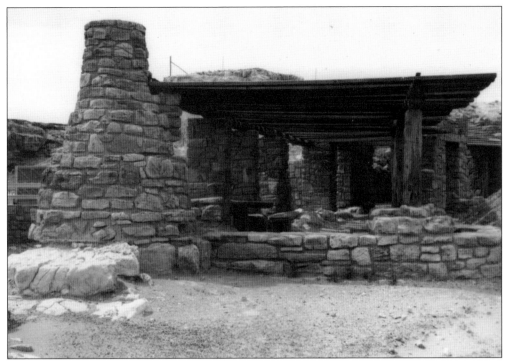

NAVAJO BRIDGE HISTORIC WAYSIDE OBSERVATION SHELTER, BUILT 1935. This shelter was commissioned by the National Park Service and built by the Civilian Conservation Corps, mostly by Navajo Indians. The design was influenced by Mary Colter (1869–1958), a famous architect and designer of many Harvey Hotels and other buildings at the Grand Canyon. She used native materials and historic local building shapes in her projects. (Jim Woodward.)

NAVAJO BRIDGE INTERPRETIVE CENTER, BUILT 1996. The interpretive center, designed by architects Jim Woodward and Jim Garrison, houses a gift shop and displays. It is built around the Historic Wayside Observation Shelter. Native stones were used to match the natural setting of the Vermilion Cliffs, and the curved walls extend out, allowing visitors to enjoy the views.

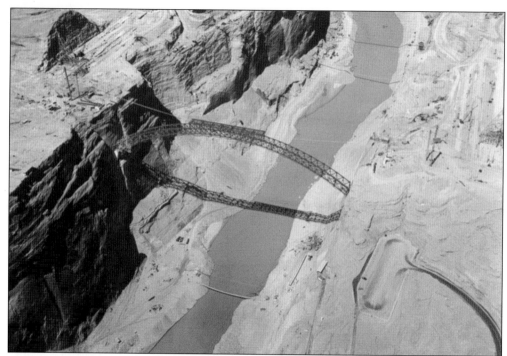

GLEN CANYON BRIDGE, BUILT 1959. This span was erected prior to the dam, to facilitate the transport of materials and workers. Prior to the bridge, a cableway across the canyon was used. The road would eventually become US Route 89. The bridge was built utilizing the cantilever method, similar to the Navajo Bridge. This vintage construction photograph shows the completed arch rib spanning the Colorado River. (US Bureau of Reclamation.)

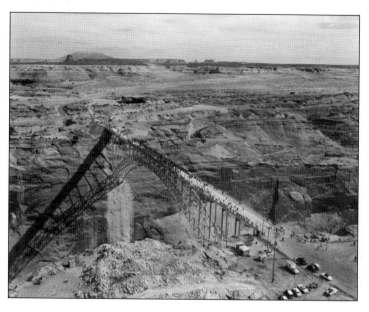

GLEN CANYON BRIDGE DEDICATION. The span was completed in February 1959, and hundreds of people, including the governors of Arizona and Utah, attended the dedication at this remote site in northern Arizona. With the completion of the bridge, US Route 89 now connected with the highway across the Colorado River. Here, people walk across the river, enjoying Glen Canyon. (US Bureau of Reclamation.)

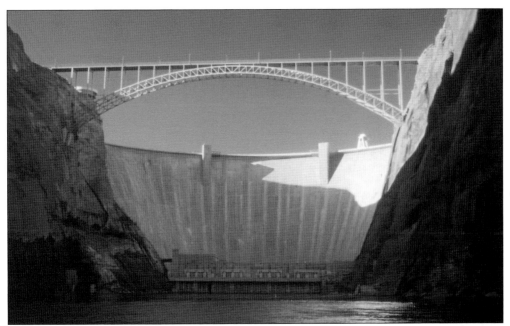

Glen Canyon Bridge and Glen Canyon Dam. The bridge, completed in 1959, and the dam, completed in 1966, are located upriver of the Navajo Bridges, near Page. The dam was built to regulate the Colorado River's flow and provide hydroelectricity to large areas of the West, at the expense of the ecosystem and historical sites. The reservoir created by the dam is Lake Powell, the second-largest artificial lake in the country. (Richard Strange.)

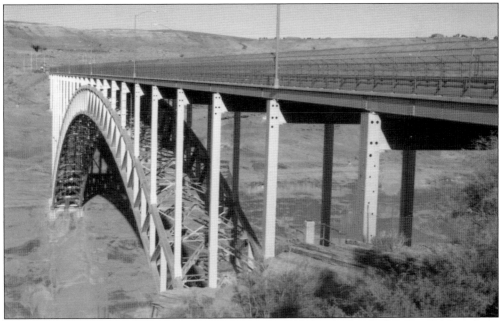

Glen Canyon Bridge. This a steel arch bridge has a span of 1,030 feet and towers 700 feet above the Colorado River. It is anchored into the canyon walls. When it was built, the bridge was the highest arch bridge in the United States. Because of its importance to the dam project, it went up in only two years.

GLEN CANYON BRIDGE WALKWAYS. The pedestrian walkways on either side of the roadway allow views of the canyon and the dam. The protective chain-link fences on both sides are used in part to keep things from going over the edge, but they certainly detract from the stunning views.

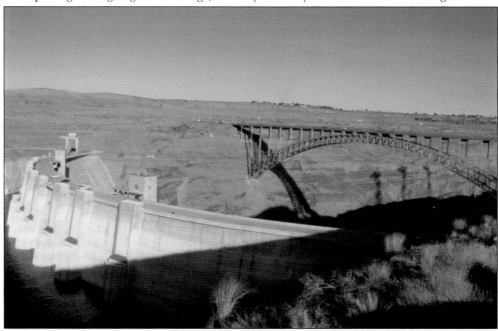

GLEN CANYON DAM. With the completion of the dam in 1966, power and water were provided to many parts of the Southwest, but it greatly modified the ecology of the Colorado River and the Grand Canyon. In the 1950s, there was a bitter fight against the dam by environmental groups, but they conceded when the government promised not to build a dam at Dinosaur National Monument.

Four

US ROUTES 89 AND 89A

US Routes 89 and 89A are part of a road system that connects Canada to Mexico, weaving along seven national parks and at least four national monuments on its way. As with most of the highways profiled in this book, parts of them had other identifying names and numbers, including the "Grand Canyon–Nogales Highway" and the "Honeymoon Trail." The road followed the trails first established by Native Americans, adventurers, and those searching for religious solitude. Before reaching the canyon from the north, a remote and harsh area of land larger than Massachusetts had to be traversed. The land was known as the Arizona Strip and had been settled by the Mormons. The Honeymoon Trail was the route young Mormon couples took to have their unions blessed at the Latter-day Saints' temples in St. George or Salt Lake City, Utah. The grueling trip via wagon often took weeks.

US Route 89 goes south from Page to Flagstaff, then to Prescott, Wickenburg, Phoenix, and Tucson, and ends near the international border with Mexico in Nogales. The route followed some of Arizona's major rivers: the Gila, the Salt, and the Santa Cruz. These rivers also served to guide early Spanish explorers, such as Francisco Vasquez de Coronado (1510–1554) and Juan Bautista de Anza (1736–788), who came up from central Mexico. As the cities grew, US Route 89 was eventually replaced with Interstate Highways 17, 10, and 19.

US Route 89A (alternate) takes off US Route 89 south of Page and crosses the Colorado River at Marble Canyon and the beautiful Vermilion Cliffs. It is the setting for the two Navajo Bridges. The road then leads into Utah. Another portion of US Route 89A starts in Flagstaff and goes south to Sedona and Prescott.

UTAH-ARIZONA BORDER, 1937. The state line, north of Fredonia, is the starting point for US Route 89 and US Route 89A, heading south through Arizona. The construction of the Navajo Bridge over the Colorado River in 1929 prompted the building of the northern segment of US Route 89. Speed limits were suggested—but not specified—on dirt roads, as is still the case today. (Arizona Department of Transportation.)

HIGHWAY 89, 1933. US Route 89, later renamed US Route 89A Highway, is seen here between Fredonia and the Navajo Bridge in the Arizona Strip. The highway was a dirt trail when the Navajo Bridge was built, and it was necessary to delay the dedication of the bridge until the road was constructed. (Arizona Department of Transportation.)

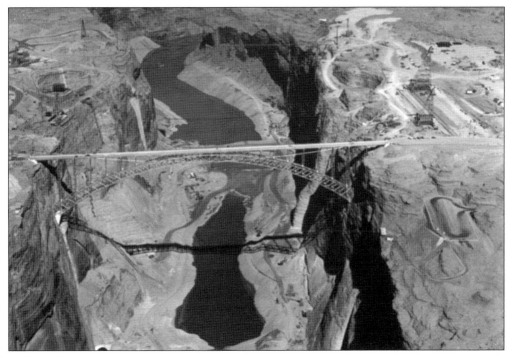

GLEN CANYON BRIDGE, BUILT 1959. Prior to the construction of the Glen Canyon Dam, a sturdy road and major bridge had to be built to reach this remote part of the canyon between Kanab, Utah, and Flagstaff, Arizona. The bridge over the Colorado River is seen here before the dam was built. The bridge carries US Route 89 traffic at Page, Arizona. (US Bureau of Reclamation.)

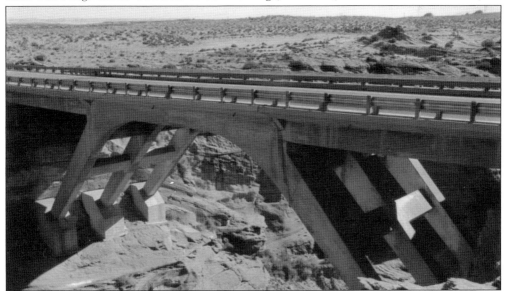

WATER HOLES CANYON BRIDGE, BUILT 1957. When the decision was made to build Glen Canyon Dam, a road was needed to traverse the 25 miles from the closest town of Bitter Springs on the Navajo Reservation to the construction site at Page. This road would become US Route 89. The bridge spanning the beautiful sandstone canyon is of an unusual design: made of concrete, featuring three spans and a rigid frame.

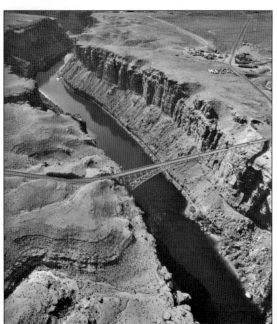

HISTORIC NAVAJO BRIDGE OVER THE COLORADO RIVER, BUILT 1929. This is the first historic bridge on US Route 89A going south from Utah into Arizona. It spans Marble Canyon about six miles downriver from Lee's Ferry. The canyon was narrow, and the approaches to it were not steep. The Sevier Valley Railway had chosen this site for a crossing in 1881, but it was not built.

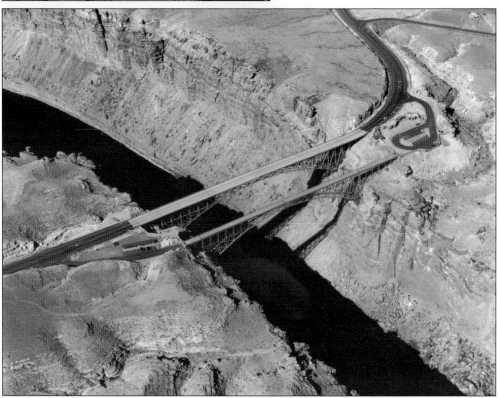

NEW NAVAJO BRIDGE, BUILT 1995. The new, wider vehicular bridge (left) runs parallel to the 1929 bridge designed by Ralph Hoffman, which was converted into an amazing pedestrian experience. The new 1995 vehicular bridge, which now carries US Route 89A traffic over the river, was needed so that tour buses and other heavier vehicles can safely travel over the river.

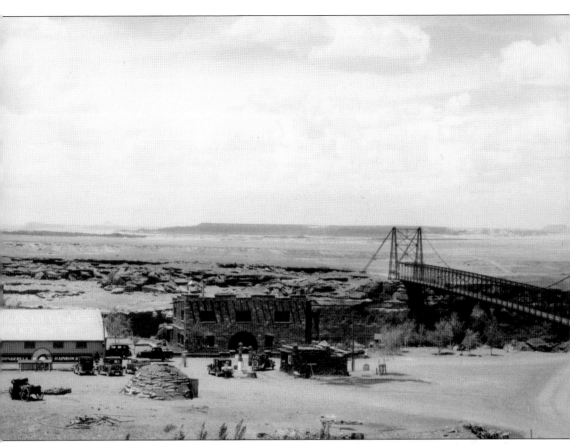

CAMERON SUSPENSION BRIDGE AND CAMERON TRADING POST. This 1933 photograph shows the bridge over the Little Colorado River and the thriving trading post in the foreground. The bridge, one of Arizona's oldest and longest (at 660 feet), was built to improve commerce on the Navajo and Hopi Reservations. It became a pivotal part of the US Route 89 North-South Highway in Arizona. Built by the Office of Indian Affairs, it was named after US senator Ralph Cameron (1863–1953), who opposed making the nearby Grand Canyon a national park. Ironically, he is buried in the park cemetery. The Cameron Trading Post, also named for the senator, is today a thriving, modernized version of the old trading post. It is a favorite stopping place for people on their way to Lake Powell and the North Rim of the Grand Canyon. (Arizona Historical Society.)

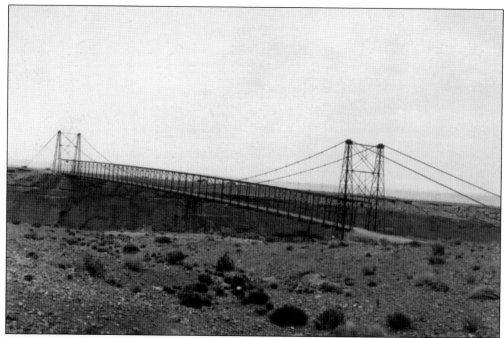

CAMERON SUSPENSION BRIDGE, BUILT 1911. The bridge's lightweight frame looks like an impossible and graceful sculpture of toothpicks and string, but it was a workhorse for 18 years, until the construction of the Navajo Bridge. The Cameron Bridge was then strengthened, but even after that, a crossing herd of sheep nearly caused it to collapse. (Arizona Department of Transportation.)

CAMERON DETOUR BRIDGE, BUILT 1957. The 1911 Cameron Suspension Bridge was retired and sold to a utility company to be used for a pipeline. An opportunity was lost to transform it into a vibrant pedestrian and tourist experience, especially considering its location next to the trading post. A temporary detour bridge, shown here, was built to carry heavy loads over the river during the construction of Glen Canyon Dam.

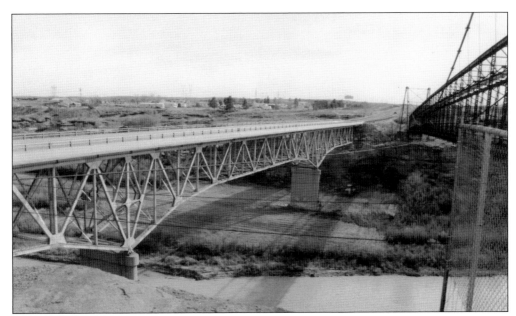

CAMERON TRUSS BRIDGE, BUILT 1959. The Arizona Department of Transportation opted to build a new bridge (left) next to the 1911 one (right) using a very different design: a three-span steel Warren deck truss structure. The suspension bridge now carries a pipeline and is closed to the public. The 1959 truss bridge, currently being replaced with a concrete girder span, will be removed.

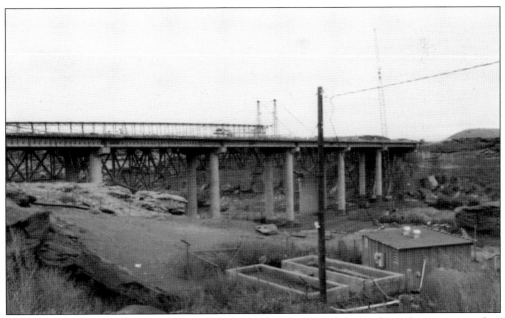

CAMERON GIRDER BRIDGE, BUILT 2015. The 1959 Cameron Truss Bridge is being removed to make space for a wider and stronger concrete girder bridge. The Cameron Truss Bridge design was similar to the Interstate 35W bridge in Minneapolis, Minnesota, which failed in 2007, due in part to the weakness of the gusset (or connection) plates. When the Arizona Department of Transportation decided to widen US Route 89 and replace the bridge, it solved two problems.

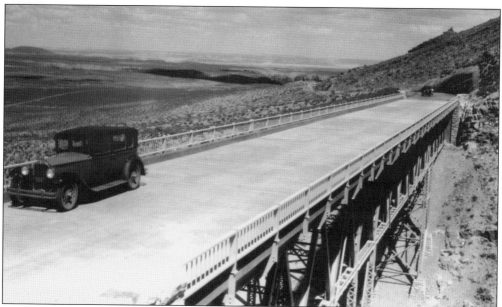

DEAD INDIAN CANYON BRIDGE, BUILT 1934. This bridge opened up access to the South Rim of Grand Canyon National Park from the east, much as the Navajo Bridge opened the North Rim. The bridge is on State Route 64, a connector road from US Route 89 to the South Rim, and is located 30 miles west of Cameron. (Arizona Department of Transportation.)

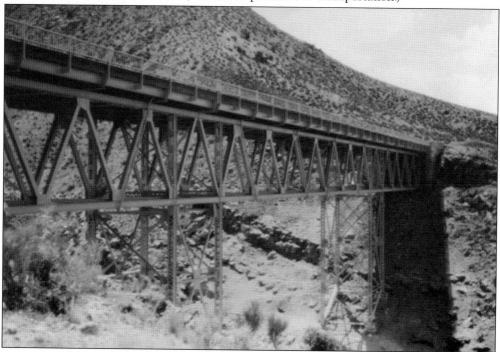

DEAD INDIAN CANYON BRIDGE. Built by the US Bureau of Public Roads, this is a three-span truss structure with steel towers, similar to the Querino Canyon Bridge on Route 66. The abutment walls include stone facing, in keeping with the National Park Service's rustic style of architecture. It is now abandoned. (Arizona Department of Transportation.)

WATCHTOWER AT DESERT VIEW, GRAND CANYON NATIONAL PARK, BUILT 1932. Mary Colter, the architect and interior designer of many Harvey House hotels, began designing buildings for the Grand Canyon in 1905 with the Hopi House. She went on to design other buildings and interiors around the West, but she returned to the canyon in the 1930s to design the Watchtower, based on ruins she had seen at Mesa Verde National Park and Hovenweep National Monument. She traveled vast distances over rugged terrain to visit these ruins and study their construction. As a result, she was instrumental in promoting the philosophy of using native materials to complement a structure's natural setting rather than dominating it. Architect Jim Woodward used these same ideas and techniques in his design of the Navajo Bridge Interpretive Center.

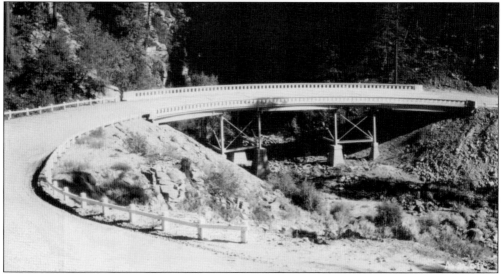

PUMPHOUSE WASH BRIDGE, BUILT 1931. The bridge on US Route 89A from Flagstaff to Sedona had to curve around the base of the mountain. Ralph Hoffman designed a five-span steel girder bridge as the solution. This 1932 photograph shows the original decorative railing, which has since been replaced with concrete Jersey barricades, a cost-effective but aesthetically inferior alternative. (Arizona Department of Transportation.)

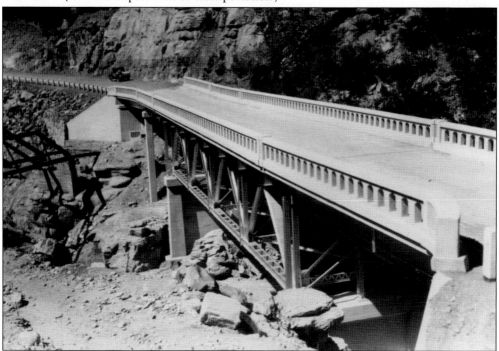

OAK CREEK BRIDGE, BUILT 1933. The original steel truss bridge (pictured) was replaced in 1991 with a concrete arch bridge. It is located on US Route 89A near Slide Rock State Park. The park is famous for a stretch of rushing creek water and smooth, slippery red sandstone that makes sliding down it, with only one's body, an exhilarating experience. (Arizona Department of Transportation.)

MIDGLEY BRIDGE, BUILT 1939. Gracefully spanning Wilson Canyon on US Route 89A between Flagstaff and Sedona, the bridge is framed by the dramatic landscape of the mystical red Sedona hills. The steel deck bridge features spandrel-braced arches, similar to those of the Navajo Bridges, giving the bridge a light and airy appearance. (Arizona Department of Transportation.)

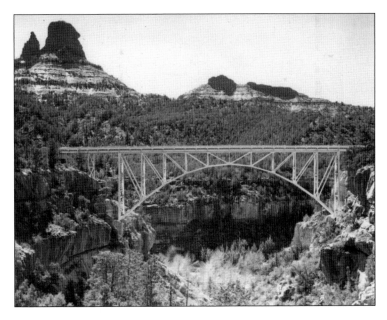

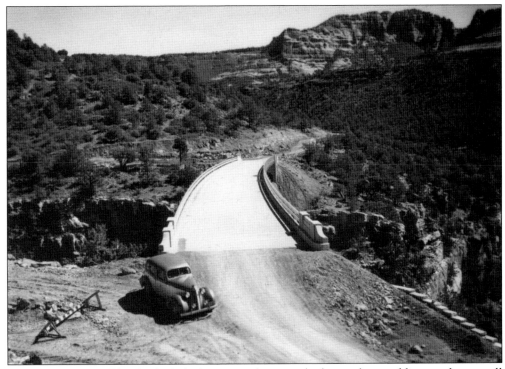

MIDGLEY BRIDGE. This bridge's deck is curved to match the roadway, adding to the overall appearance of the bridge. It was designed by the US Forest Service as the final leg of the route between Sedona and Flagstaff. The bridge's namesake, W.W. Midgley, was an important local rancher in the 1880s. (Arizona Department of Transportation.)

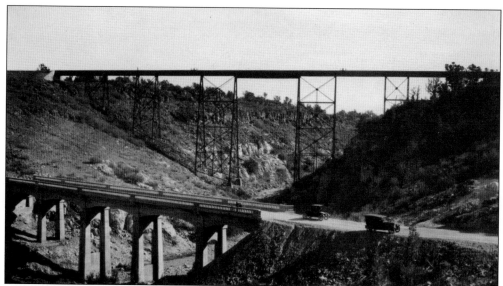

HELL CANYON BRIDGE, BUILT 1923. The Arizona Department of Transportation built the 50-mile Prescott to Ash Fork Highway, which would later become part of US Route 89. The largest expense was the five-span concrete arch bridge over Hell Canyon (foreground), paralleling the Santa Fe Railroad trestle (background). The road bridge was abandoned in 1954 when US Route 89 was realigned. (Sharlot Hall Museum.)

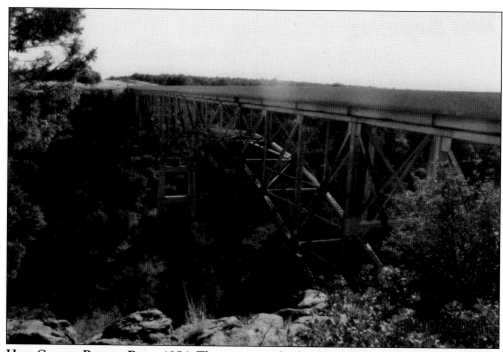

HELL CANYON BRIDGE, BUILT 1954. The canyon at this location is deep, so falsework could not be used. A three-span cantilever truss with clean proportions was chosen as the design solution, and it fits elegantly into the canyon. It also offers the traveler a chance to look at the beautiful views below. The bridge is located in the 9,900-acre Hell's Canyon Wilderness Area.

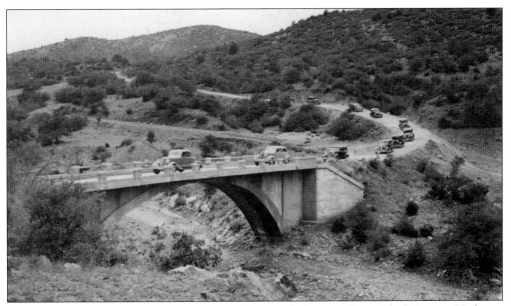

Lynx Creek Bridge, Built 1922. This 1936 photograph shows traffic on Black Canyon Highway, a few miles east of US Route 89. It was a former stagecoach route that connected Prescott's Fort Whipple with other Arizona military bases. This spandrel concrete arch bridge was retired in 2000, when a new road bridge was built. This one now serves pedestrians in a beautiful riparian setting. (Sharlot Hall Museum.)

Lynx Creek Gravesite. Angeline Hoagland was the daughter of a pioneer mining family that worked a placer claim along Lynx Creek in the 1800s. She died at a young age and was lovingly buried near the bridge, marked by a gravestone inscribed with verse composed by historian Sharlot Hall, for whom the museum in Prescott is named.

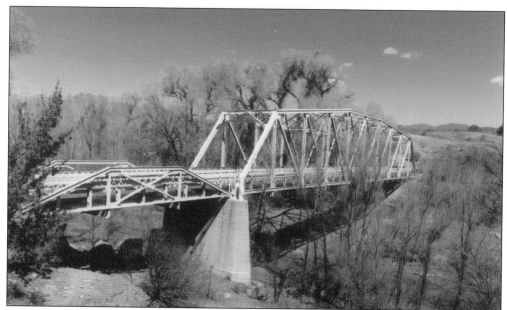

Walnut Grove Bridge, Built 1924. This existing bridge over the Hassayampa River, not far from US Route 89, was built by Yavapai County at the insistence of local ranchers. The truss's unique camelback shape was ideal for shorter canyons or could be combined in a series to cross the wider rivers, such as the Gillespie Dam Bridge on US Route 80.

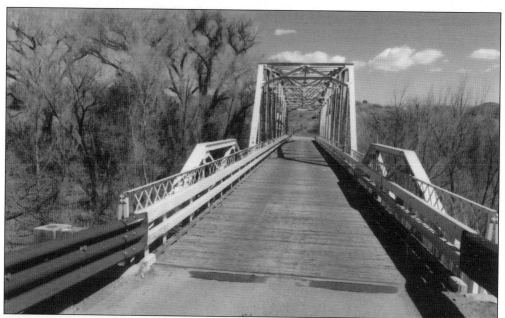

Walnut Grove Bridge. Though a county project, this bridge's design was overseen by Ralph Hoffman of the Arizona Department of Transportation. Local governments at that time relied heavily on the state government's varied and keen technical minds for advice on design and construction. The bridge was rehabilitated in 2008, including a new wooden deck, repainting trusses, and other miscellaneous work.

WICKENBURG BRIDGE, BUILT 1921. In 1914, Maricopa County built a four-span concrete bridge over the Hassayampa River on US Route 89. The bridge suffered extensive damage during the 1919 flood. In 1921, a replacement three-span steel Pratt through truss bridge (pictured) was built over the Hassayampa River. It carried traffic until the steel truss bridge was replaced with a steel girder bridge in 1937. (Arizona Department of Transportation.)

BOULDER CREEK BRIDGE, BUILT 1937. The trusses from the Wickenburg Bridge were dismantled and erected over Boulder Creek. The move to State Route 88 shows the portable nature of steel trusses. The bridge remains today and is used on this low-volume recreational road in eastern Maricopa County.

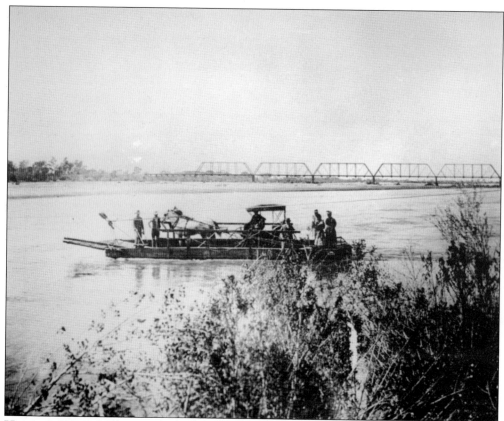

HAYDEN'S FERRY. In the 1870s, the Salt River ran continuously, making it difficult to cross the river during high flows. During low flows, a horse and buggy could easily navigate the crossing. Charles Hayden noted this situation and built a cable ferry (pictured). His son Carl Hayden, the state's first US congressman, also recognized the need for a bridge and championed funding for many Arizona public works projects. (Wikimedia Commons.)

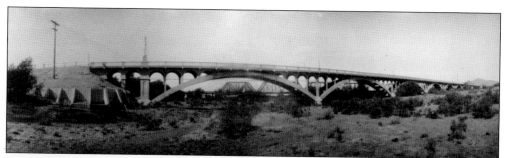

TEMPE BRIDGE (ASH AVENUE BRIDGE), BUILT 1913. Leaving Wickenburg on US Route 89, the highway travels through Phoenix on Van Buren Street to Tempe and the Salt River. Seen here, the 1913 Ash Avenue Bridge carried traffic until the Mill Avenue Bridge was built in 1931. (Arizona Department of Transportation.)

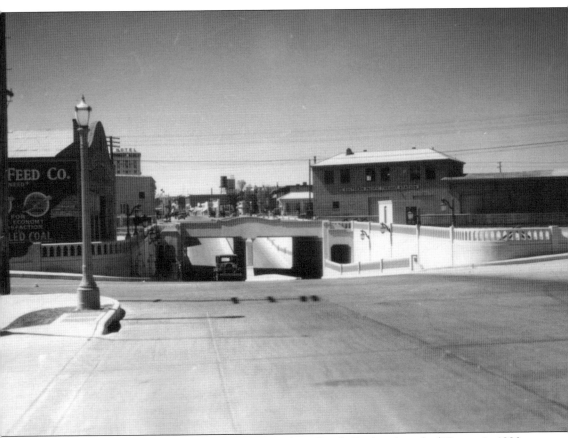

Stone Avenue Underpass, Built 1936. The Southern Pacific Railroad reached Tucson in 1880 and became a major supply and distribution route for the mining industry in southern Arizona and Mexico. With the main line of the railroad passing through the city, three underpasses were built (in 1916, 1930, and 1936) to handle the north-south road traffic in the burgeoning downtown. The Stone Avenue Overpass, still in use today, was the last of the three to be built, but it was the only one on the former US Route 89. Each of the underpasses features distinct architectural styles. The underpass at Stone Avenue has curved parapets and arched couplings in the Mission style. (Arizona Department of Transportation.)

SIXTH AVENUE UNDERPASS, BUILT 1930. Sixth Avenue runs east of and parallel with Stone Avenue. This bridge still exists in much the same state as when it was built. It was built in the Classical Revival style. The car in this vintage photograph, approaching the underpass, greatly contrasts with the heavy traffic of current times. (Martha Dalton.)

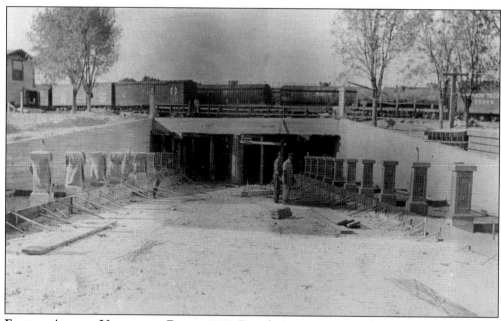

FOURTH AVENUE UNDERPASS, BUILT 1916. Fourth Avenue is east of the other previous two underpasses. Before it was replaced with a new underpass in 2009, it was the oldest urban-grade separation in Arizona, designed in the Classical Revival style with recessed panels cast into the concrete. Tucson received federal funds to build a modern streetcar, and the underpass had to be reconstructed.

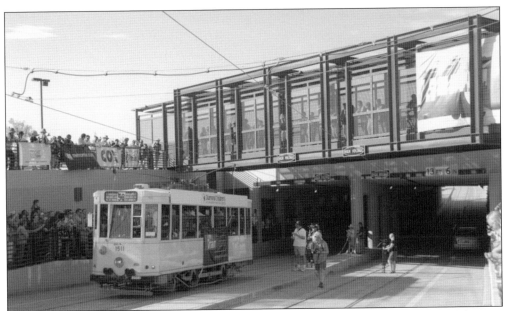

FOURTH AVENUE UNDERPASS, BUILT 2009. This photograph shows the dedication of the new underpass, which replaced the old one on the same alignment. The City of Tucson solicited extensive input from the citizens and decided to save the historic underpass for pedestrians and build one adjacent for vehicles and the streetcar. Ultimately, however, the 1916 underpass was demolished after additional lobbying from a developer.

NEW FOURTH AVENUE UNDERPASS. The interior of the underpass provides space for streetcars, vehicles, bicycles, and pedestrians to travel under the railroad. The underpass design is modern, rather than being a reflection of the past. The concrete, oval-shaped columns reduce the visual impact of the many supports. The modern design successfully fulfilled the city's desire to provide a well-lit and safe pedestrian experience in the underpass.

SANTA CRUZ RIVER BRIDGE, BUILT 1917. US Route 89, now Interstate 19, went south from Tucson to Nogales and the international border with Mexico. The Santa Cruz River flows south to north, just like the San Pedro River. This bridge, about six miles east of the old US Route 89, was a vital connector to it. It is also one of the oldest existing vehicular bridges in Arizona.

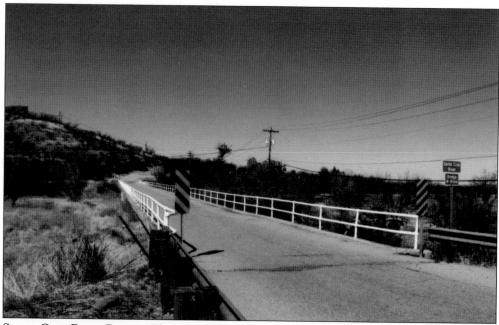

SANTA CRUZ RIVER BRIDGE. This is a 465-foot-long, one-lane concrete girder bridge with a metal pipe barrier rail. State engineer B.M. Atwood located the site for this bridge and designed it using a two-girder design, but the members were massive and costly. The only remaining two-girder bridges in Arizona are this one and the Antelope Bridge on US Route 80.

Five

NOTEWORTHY BRIDGES

By the early 1900s, the labor-intensive masonry arches were no longer economical, so designers turned to reinforced concrete, which had recently been developed by European engineers. The first known reinforced concrete arch bridge in the United States was designed by Ernest L. Ransome in 1889, located in Golden Gate Park in San Francisco. In Arizona, the oldest remaining concrete arch bridge, the Alchesay Canyon Bridge, was built in 1905 near Roosevelt Dam. In 1907, two concrete arch bridges, the Solomonville Road Overpasses, were erected in Greenlee County. These three are the oldest bridges in Arizona.

Concrete girder bridges, however, had strength limitations related to any span longer than 65 feet. Steel trusses came into vogue and were embraced by Arizona state engineer Lamar Cobb, but they were more expensive than concrete. Cobb turned to Daniel Luten (1896–1946), a nationally recognized designer and patent owner of longer-span reinforced concrete arches. In Arizona, his first bridge was the Canyon Padre Bridge, with a span of 136 feet. This was later followed by the longest span, 174 feet, over the Little Colorado River Bridge in Holbrook. A total of 13 Luten arch bridges were built in Arizona, of which seven have been rehabilitated and six are still in need of repair. Daniel Luten and other engineers at that time were influenced by the City Beautiful movement in the early 20th century, championed by Daniel Burnham and highlighted at the 1893 Chicago World's Fair. It was an effort to build structures that were aesthetically pleasing as well as functional.

Luten arches worked for some situations, but even longer spans were needed. In 1929, Ralph Hoffman was Arizona's state bridge engineer, having started with the department in 1918. He completed the design of the Navajo Bridge over the Colorado River using a steel arch design, the most important bridge in his career. Hoffman, more than any other engineer, influenced bridge design in Arizona. Some of his other bridges are profiled here. He left the highway department in 1954 to start his own engineering firm.

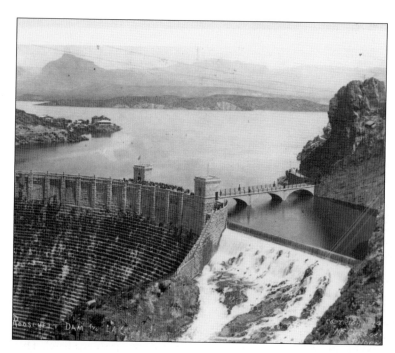

ROOSEVELT DAM, BUILT 1911. Construction began on this dam on the Salt River in 1906, when Theodore Roosevelt was still president. It was finished in 1911 after he had left office, but it was still named for him. The dam was built to provide another water supply to the growing city of Phoenix. This photograph shows the dam before its height was increased. (Library of Congress.)

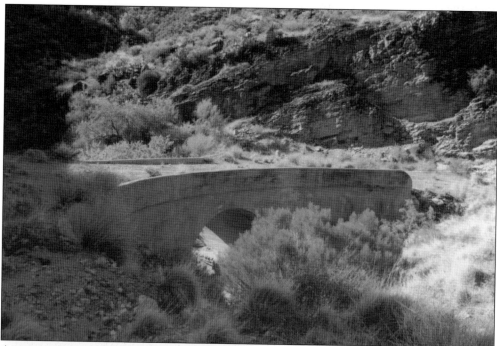

ALCHESAY CANYON BRIDGE, BUILT 1905. Located near the Roosevelt Dam on the Apache Trail, this is the oldest remaining vehicular bridge in Arizona, built to provide access to the dam. By the early 1900s, labor-intensive masonry arches were not economical, and reinforced concrete became a cost-effective alternative. This bridge was expertly built by a crew of Apache Indians.

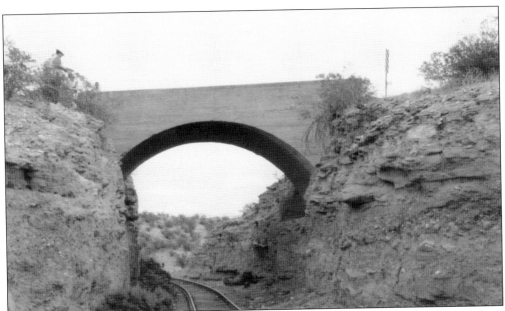

SOLOMONVILLE ROAD OVERPASSES, BUILT 1907. Though very modest in scale and design, these two overpasses are the next-oldest bridge structures in Arizona (only one is shown here). They were on the Solomonville toll road between Safford and Clifton on what is now called the Black Canyon Back Country Byway. Toll roads were very common in the early days of automobile travel, before the federal and state governments took on some of that responsibility.

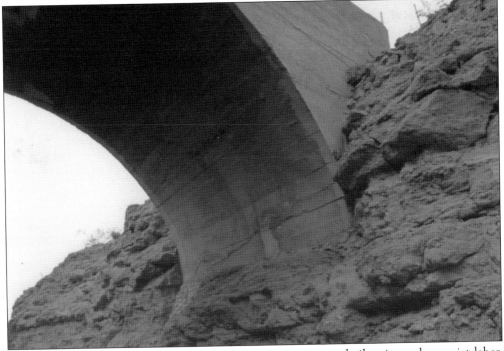

BELOW SOLOMONVILLE ROAD OVERPASS. These overpasses were built using only convict labor. They are still is use today. They provide access, free of tolls, to Bureau of Land Management recreational areas and private ranches.

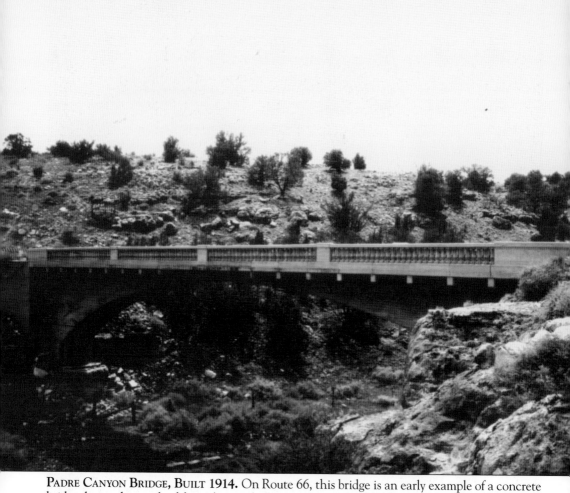

PADRE CANYON BRIDGE, BUILT 1914. On Route 66, this bridge is an early example of a concrete bridge design that evolved from the purely functional style of the Solomonville Road Overpasses. Lamar Cobb, the state's bridge engineer, found that building concrete bridges with local labor was much cheaper than having steel trusses fabricated in the Midwest and shipped out. At that time, the Arizona Department of Transportation had only used heavy concrete girder bridges, with limited spans of 65 feet. This canyon, however, needed a span twice that long, so he turned to Daniel Luten, the nation's preeminent designer of concrete flat arches, to design this bridge. Luten, who was influenced by the City Beautiful movement, not only built a bridge that still exists, but added decorative railings that would be mirrored on other bridges throughout Arizona. (Arizona Department of Transportation.)

WINKELMAN BRIDGE, BUILT 1916. Pinal County built two Luten concrete arch bridges over the Gila River, with one at Kelvin and the other at Winkelman. The Kelvin Bridge is currently used for vehicular traffic, but Pinal County plans to convert it to a pedestrian bridge, as was done for the Winkelman Bridge. This photograph shows the Winkelman Bridge with its decorative barrier rail in need of repair.

WINKELMAN BRIDGE, RESTORED 1994. The decorative concrete barrier rail was replaced with a modern replica when the bridge was restored by the town of Winkelman. This photograph shows the bridge at its rededication ceremony. It is now a focal point for the town of Winkelman and used as a pedestrian bridge and as a setting for community events.

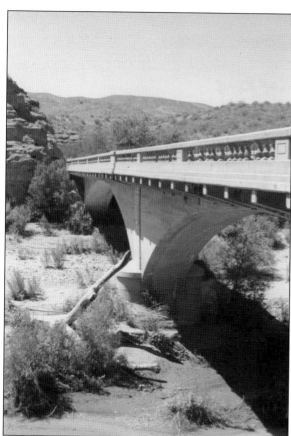

GILA RIVER BRIDGE, BUILT 1918. The Arizona Department of Transportation's Clifton-Solomonville Road generally followed mountain ridges, but crossing the Gila River was unavoidable. After pricing a steel deck bridge, the department again turned to Daniel Luten. He used prison labor to build a cheaper but elegant two-span concrete arch bridge. It remains one of Arizona's significant bridges and is a testament to his skills and the local labor pool.

GILA RIVER BRIDGE, REHABILITATED 1995. The underside of the Gila River Bridge shows the curved flat arch that made Daniel Luten famous. Greenlee County renovated the bridge, replacing the deteriorated barrier rail with a replica. The bridge is located on the Black Canyon Back Country Byway, just a few miles from State Route 191 and the Solomonville Road underpasses.

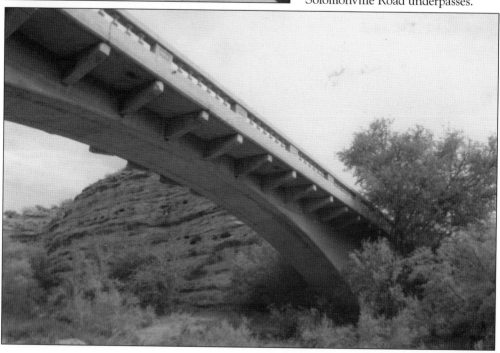

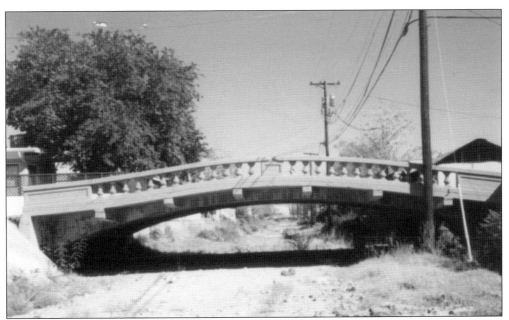

TOWN OF MIAMI BRIDGES, BUILT 1921. While the Arizona Department of Transportation was looking for longer span bridges, the Town of Miami built five Luten arch bridges over Bloody Tanks Wash, each with a 50-foot span. This photograph shows one of the Miami Bridges, with the decorative barrier rail in need of repair. The hump is a technique to reduce speeds on the bridge.

TOWN OF MIAMI BRIDGES, RESTORED 2004. Restoration of these bridges included replacing Luten's signature barrier rails with modern replicas and placing new streetlights on the bridges at mid-span. The original structure, however, has not changed, and Luten's humps have allowed the town to post a 15 mph speed limit.

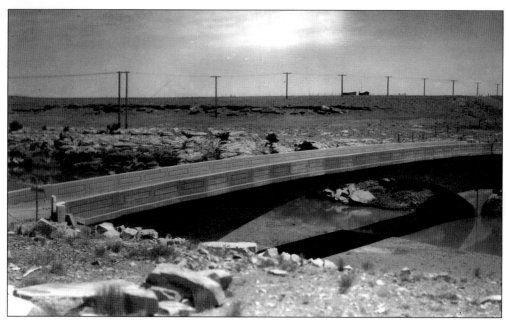

HOLBROOK BRIDGE, BUILT 1916. This concrete arch has a span of 174 feet over the Little Colorado River. It is the longest Luten arch span in the United States. The bridge replaced a steel truss structure that was washed away in the 1915 Lyman Dam flood. It carried local traffic until 1975, when a new bridge was built upriver. (Arizona Department of Transportation.)

HOLBROOK BRIDGE. This bridge, now in private ownership on a local ranch road, is in need of maintenance. This photograph shows earth material hiding the concrete barrier on the right. The Holbrook Bridge, one of Arizona's most important early vehicular spans, is located about 15 miles east of Holbrook and a few feet north of US Route 180.

RALPH HOFFMAN (1894–1967). Hoffman started as a draftsman in the Arizona Department of Transportation in 1918 after graduating from the University of Oklahoma. He quickly advanced and became the state bridge engineer five years later, holding that position until 1954. He supervised the design of all major bridges. In 1954, he left to start his own consulting firm, Hoffman-Miller Engineers, which became Arizona's most important bridge consulting firm. In a 1934 *Arizona Highways* magazine article, Hoffman wrote about designing bridges to blend with the natural environment rather than competing with it. With that goal in mind, he chose designs that usually put the mass of the structure underneath the bridge deck and used low railing that drivers could see over. (Mary Lou Vaughan.)

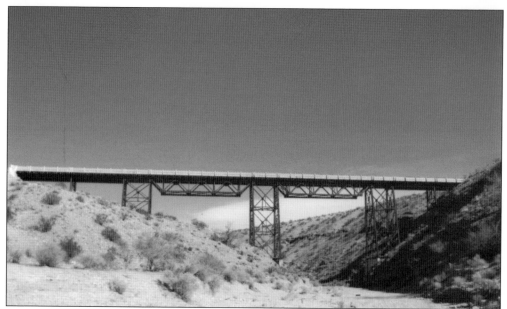

Sand Hollow Wash Bridge, Built 1930. This bridge illustrates Hoffman's philosophy of putting most of the structure underneath, allowing motorists to view the canyon. The bridge's elegant steel construction is seen from below. Located near the Nevada-Utah border, the bridge provided an important access from Las Vegas, Nevada, to Utah via the beautiful Virgin River Gorge, until Interstate 15 was built a few miles away.

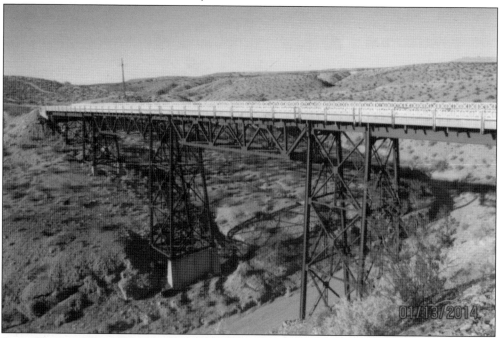

Sand Hollow Wash Bridge. The multi-span steel trestle has tall steel pier towers. It has an appearance similar to the Querino Canyon Bridge on Route 66 in Apache County, also designed by Ralph Hoffman. It now serves as a local Mohave County road about five miles east of Mesquite, Nevada, on old US Route 91.

SALT RIVER CANYON BRIDGE, BUILT 1934. US Route 60 plummets into the canyon on a steep curved roadway to the Salt River at the bottom. The canyon narrows at this point, providing a perfect site for a Hoffman bridge. The highway then launches up from the river and snakes back and forth before finally reaching the plateau above. It is one of the scarier but more beautiful drives in the state. (Arizona Department of Transportation.)

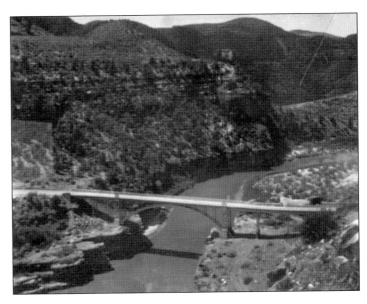

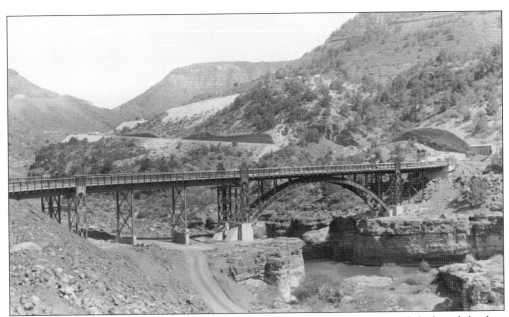

SALT RIVER CANYON BRIDGE, BUILT 1934. This was one of five similar steel deck arch bridges that Hoffman designed on US Route 60 between Superior and Show Low. The bridge carried US Route 60 traffic until 1997, when it was converted to a pedestrian bridge. A new vehicle bridge and rest stop were built. (Mary Lou Vaughan.)

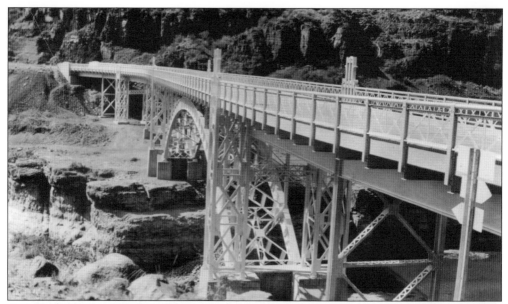

SALT RIVER CANYON BRIDGE. Designed by Hoffman, this bridge was a departure from the plain and utilitarian structures that were the standard of the Arizona Department of Transportation. This bridge featured decorative steel pylons at the piers, decorative steel barrier rails, and a curved deck to match the highway. It clearly illustrates the influence of Hoffman's design philosophy. (Arizona Department of Transportation.)

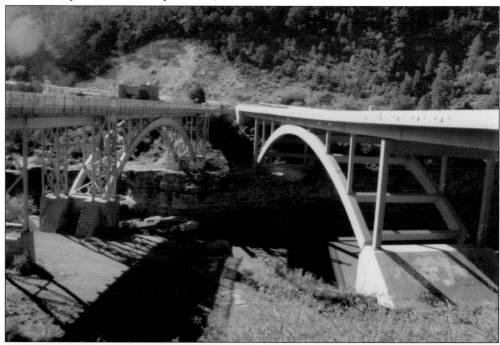

SALT RIVER CANYON BRIDGE, BUILT 1997. This photograph showcases the two Salt River Canyon Bridges. The bridge on the right uses a modern steel arch with a concrete barrier, rather than steel see-through barrier rails. The two bridges, so different in style and materials and being so close to each other, are visually distracting.

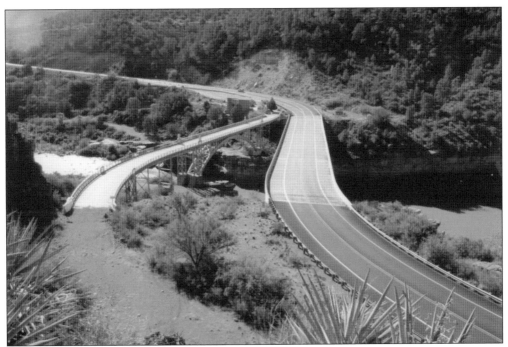

SALT RIVER CANYON BRIDGES. The 1934 bridge (left) features Hoffman's design of a curved deck, matching the approach roadways of US Route 60 on each side. This was a departure from the previous practice of crossing a watercourse at a right angle. The two bridges, so close together with such different alignments, are visually distracting.

SALT RIVER CANYON. The Jimana Inn, seen in this 1944 photograph, is located at the bottom of the canyon, just off US Route 60. The White Mountain Passenger Lines van is similar to the vans used by the Fred Harvey tours. Today, this local inn is abandoned and in a sad state of disrepair. (Arizona Department of Transportation.)

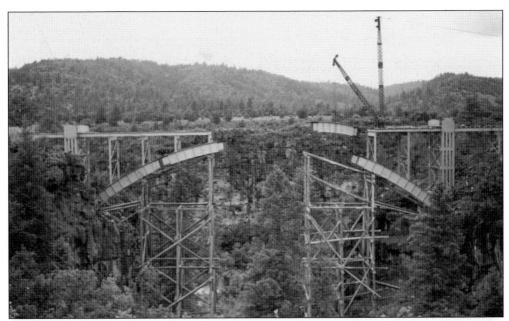

CEDAR CANYON BRIDGE, BUILT 1938. This bridge on US Route 60 near Show Low is another of Hoffman's steel arch designs. This 1937 photograph shows the steel arch being built using temporary falsework to support the arch until the steel members are connected at mid-span. The crane, supported on falsework, is lifting a segment of the arch into place. (Arizona Department of Transportation.)

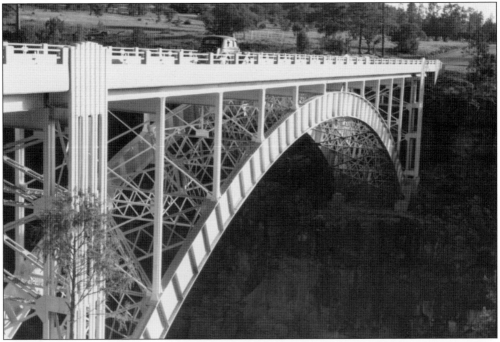

CEDAR CANYON BRIDGE. This structure is very similar to the one in the Salt River Canyon. This bridge also featured Art Deco steel pylons at the piers and decorative see-through steel barrier rails. (Arizona Department of Transportation.)

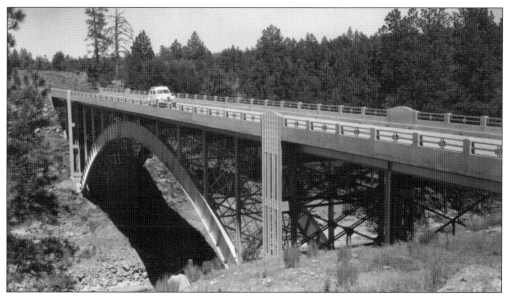

CORDUROY CREEK BRIDGE, BUILT 1938. Another canyon on US Route 60 closer to Show Low also needed a bridge. The Arizona Department of Transportation used the same design and span dimensions on the Corduroy Creek Bridge as that used on the bridge over Cedar Canyon. (Arizona Department of Transportation.)

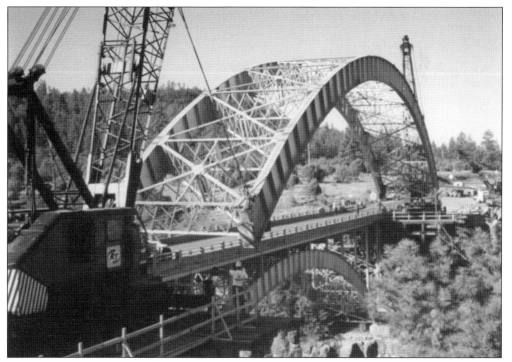

CEDAR CANYON BRIDGE, WIDENED 1993. After more that 50 years of service and increasing traffic, both bridges needed work. In an innovative move by the Arizona Department of Transportation, the bridge over Corduroy Creek was dismantled, and the arches were moved to the Cedar Creek Bridge to widen it. A new girder bridge was then built over Corduroy Creek.

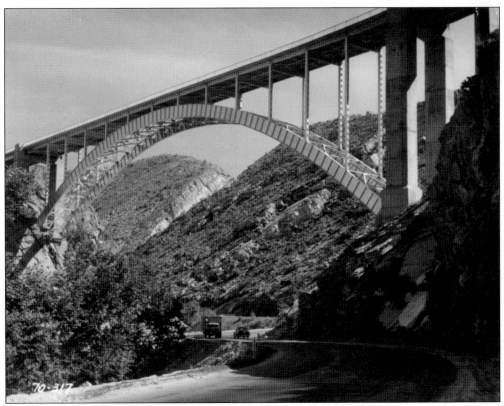

QUEEN CREEK BRIDGE, BUILT 1949. This Hoffman-designed steel arch bridge was built as part of a realignment of US Route 60 north of Superior. This vintage photograph shows the new bridge and vehicles traveling below along Queen Creek via an older alignment. (Arizona Department of Transportation.)

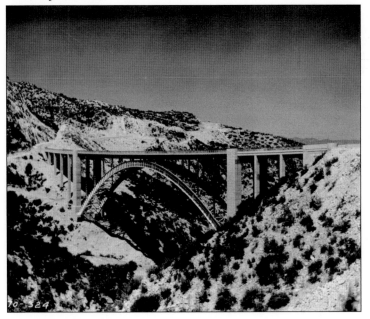

PINTO CREEK BRIDGE, BUILT 1949. This bridge carries US Route 60 highway over Pinto Creek near Miami, Arizona. As with the Salt River Canyon, Cedar Canyon, Corduroy Creek, and Queen Creek Bridges, this had aesthetic treatments of the piers. Also, like these other bridges, the mass of the structure was placed below the surface of the bridge roadway to prevent obscuring the view of the natural scenery. (Mary Lou Vaughan.)

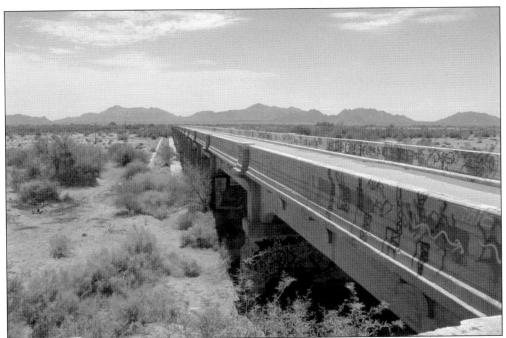

Sacaton Dam Bridge, Built 1925. This is a concrete girder structure. It has 25 spans and is 1,508 feet long, making it one of the longest bridges in Arizona. It was built using Indian laborers. The diversion dam has deteriorated, but the bridge remains on a low-volume road on the Gila Indian Reservation. The bridge has been heavily tagged with graffiti.

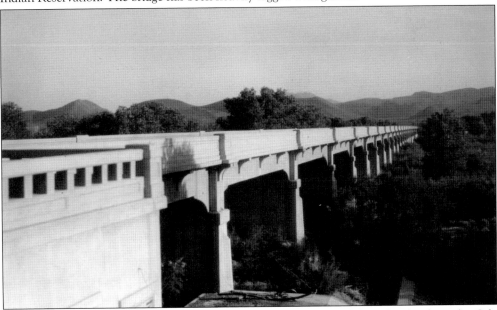

Sacaton Dam Bridge. The Pima and Maricopa Indians irrigated their farmlands in the Gila River Valley until the Anglos diverted large quantities of water from the river. The federal government built a diversion dam and bridge over the Gila River in order to help compensate the Indians for their water losses. This bridge is near the town of Olberg. (Arizona Department of Transportation.)

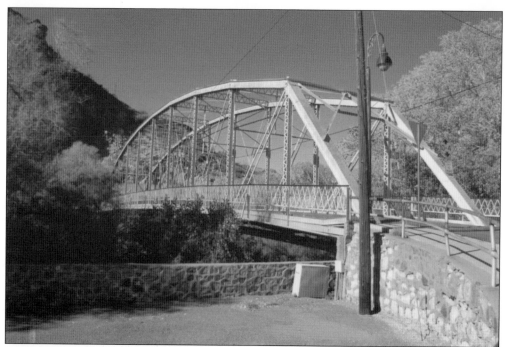

PARK AVENUE BRIDGE, BUILT 1918. This bridge crosses the San Francisco River in the middle of the small mining town of Clifton in eastern Arizona. In 1917, the Clifton Town Council contracted with the Midland Bridge Company of Kansas City, Missouri, to design and build it. Many local governments used national steel bridge contractors and their catalogs of readymade designs.

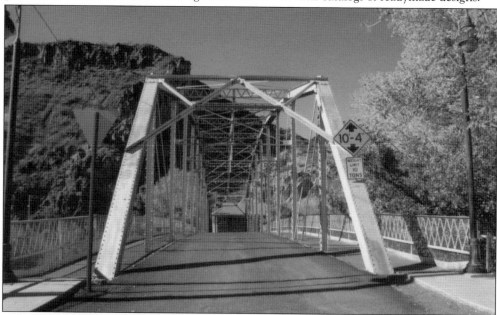

PARK AVENUE BRIDGE. This is a riveted Parker through steel truss bridge that has a span of 220 feet. It is one of two remaining pin-connected truss bridges in Arizona. The other pin-connected bridge is the Ocean-to-Ocean Highway Bridge in Yuma. It has an 18-foot-wide roadway with pedestrian walkways on each side of the trusses.

Six

BRIDGE TYPES

Many of Arizona's historic bridges have been profiled in this book, and some technical terms have been used to describe them. This chapter attempts to identify such terms by using vintage photographs of the following bridge types: girder, truss, arch, and suspension bridges. The last two photographs show the structural details of two different steel truss bridges that have proven to be vulnerable; people died when these bridges failed. Concrete and wooden bridges have also had their share of failures. Such failures have been wake-up calls for engineers.

How safe are these older bridges? The answer to this question depends on regular maintenance, frequent inspections, and modern load analysis. Following the 1967 failure of the Silver Bridge in West Virginia, a national bridge-inspection program was started by the US Congress. In 2007, another major failure occurred on the Interstate 35W bridge over the Mississippi River in Minneapolis, Minnesota. It was linked to the deficiency in the thickness of the gusset plates that hold the structure together. This accident further affirmed the need for regular inspections and even more structural scrutiny.

Should these old bridges be saved? Some of them are unique and beautiful but require rehabilitation in order to remain viable for cars or pedestrians. However, they should be saved. Bridges can be a major tourism draw, as has been shown with the Ocean-to-Ocean Highway Bridge in Yuma and the park, museum, and hotel that now make up part of that vibrant public space. The same is true of London Bridge in Lake Havasu City. Some other existing bridges shown in this book may not have large volumes of traffic, but they are vitally and fiercely connected to the community and offer a visual reminder of Arizona's history and the creative souls that embraced it.

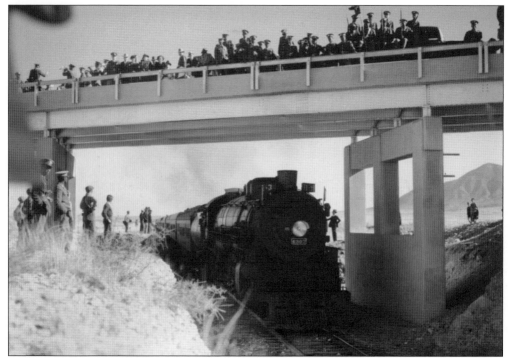

GIRDER BRIDGE (BEAM BRIDGE). The girders are the horizontal beams that support the deck and all the happy people seen here. The girders attach to the upright piers on either side of the train. These bridges are often used today on modern highways for shorter spans. The location of this photograph is not known. (Arizona Department of Transportation.)

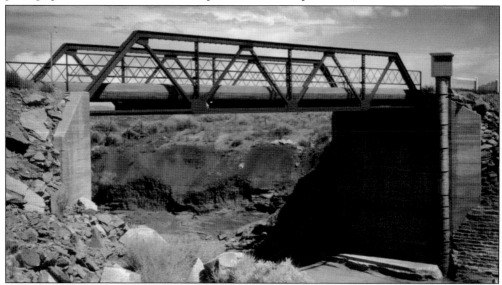

PONY TRUSS BRIDGE. This bridge has short steel trusses on each side of the roadway. This type of bridge is generally used for shorter spans. Popular for pedestrian and multiuse paths, this style is rarely used today for vehicular bridges. The Hereford Bridge and the Obed Road Bridge are exceptions, in that their builders purposefully copied the historic design. Shown here is the bridge spanning the Little Colorado River near Holbrook. (Arizona Department of Transportation.)

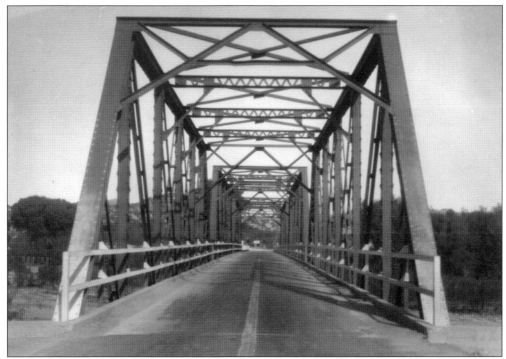

THROUGH TRUSS BRIDGE. The steel trusses on each side of the roadway are braced by more steel on the top to further strengthen it. This style was used in the early 1900s for moderate-length spans, but it is rarely used today. The bridge shown here is located on the Hassayampa River. (Arizona Department of Transportation.)

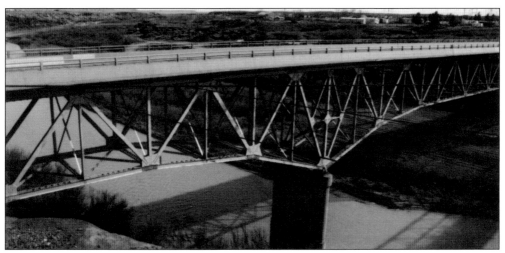

DECK TRUSS BRIDGE. The steel trusses are below the concrete roadway deck in this design, which was generally used for longer span bridges over canyons that had plenty of room for the deeper trusses. This deck truss bridge spans the Little Colorado River at Cameron.

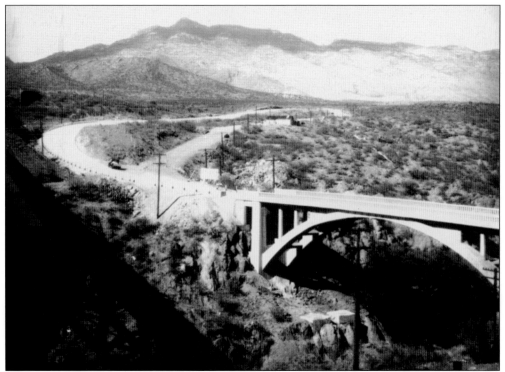

ARCH BRIDGE. The curved shape of the arch members pushes against the sides of the canyon when it is loaded with weight, thereby stabilizing it. This arch shape has been used on many Arizona bridges, from the oldest to the newest, including this one at Cienega Creek. (Arizona Department of Transportation.)

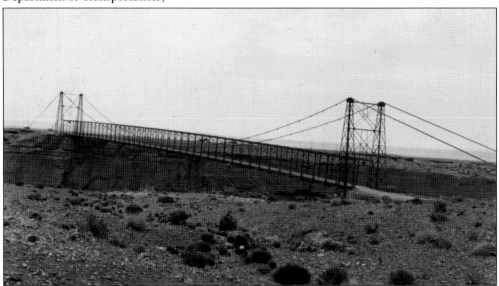

SUSPENSION BRIDGE (CABLE BRIDGE). This photograph shows a suspension bridge, with the cables draped over the two towers and anchored into the ground at each end. The cables are loaded by the vertical hangers that support the bridge deck. Suspension bridges are used for long spans. This bridge spans the Little Colorado River in Cameron. (Arizona Department of Transportation.)

PIN-CONNECTED EYEBAR FAILURE. Steel truss members connected by eye bars with a pin can be seen at the top of the truss in this photograph. In 1967, the Silver Bridge in West Virginia collapsed because of a fractured eye bar connection, resulting in 46 fatalities. This incident spurred the US Congress to require that national inspection standards be adopted to ensure the safety of the traveling public.

GUSSET PLATE FAILURE. Steel truss members are connected by gusset plates (the thin plate with all the bolts in it) in this photograph. In 2007, the Interstate 35W bridge in Minnesota failed, resulting in 13 fatalities. In that case, the gusset plates were not thick enough. Engineers are now required to pay closer attention to gusset plates in the design and inspection of bridges.

DISCOVER THOUSANDS OF LOCAL HISTORY BOOKS FEATURING MILLIONS OF VINTAGE IMAGES

Arcadia Publishing, the leading local history publisher in the United States, is committed to making history accessible and meaningful through publishing books that celebrate and preserve the heritage of America's people and places.

Find more books like this at
www.arcadiapublishing.com

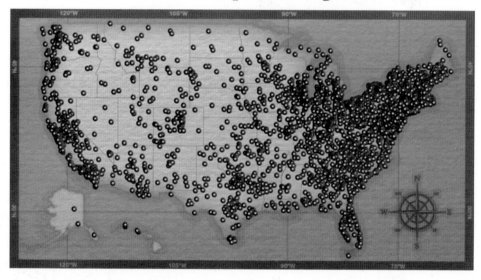

Search for your hometown history, your old stomping grounds, and even your favorite sports team.